"The camera is just a tool, and anyone who thinks making a movie is about knowing how to use a camera is destined to fail. In *Master Shots*, Christopher Kenworthy offers an excellent manual for using this tool to create images that arouse emotional impact and draw the viewer into the story. No matter what camera you're using, don't even think about turning it on until you've read this book!"
— Catherine Clinch, publisher, MomsDigitalWorld.com

"Though one needs to choose any addition to a film book library carefully, what with the current plethora of volumes on cinema, *Master Shots* is an essential addition to any worthwhile collection."
— Scott Essman, publisher, *Directed By* magazine

"Christopher Kenworthy's book gives you a no-holds-barred, no-shot-forgotten look at how films are made from the camera point of view. For anyone with a desire to understand how film is constructed — this book is for you."
— Matthew Terry, screenwriter/director, columnist for HollywoodLitSales.com

"*Master Shots* might seem like a straightforward text on tackling cinematography, but once you start reading, you soon realize it isn't meant just for directors and cinematographers — it's also a terrific reference source for producers and screenwriters looking for ways to inject energy into their projects and visually enhance their storytelling. Author Christopher Kenworthy lays out his knowledge in a clear-cut, no-nonsense fashion, from how to build more tension into a horror/thriller film, to how to capture the steamy chemistry in a love/sex sequence, to how to get the most out of a chase scene!"
— Kathie Fong Yoneda, seminar leader, producer, author of *The Script-Selling Game: A Hollywood Insider's Look at Getting Your Script Sold and Produced*

"This book is a crisp telling of shot set-up and chases, but the amazing thing is the book clearly written, with the shot theorie illustrated; it shows you exactly how and w angles and lenses to accomplish first-class camerawork at any budget level and look like the big-screen, big-budget films we're used to seeing. Really, a must have."
— Richard La Motte, independent filmmaker, author of *Costume Design 101*

"If you're looking for an easy-to-understand guide to putting your vision on film in a powerful way, I don't know of any better book to start with. The way Kenworthy breaks down shots makes it so clear and simple I was inspired to pick up a camera and start filming! And if you're a writer, you *must* read this. Understanding the way shots are actually set up will not only give you a greater visual sense but also increase your ability to write scripts that can actually be filmed! This is a worthy addition to any filmmaker's library."
— Derek Rydall, screenwriter, author of *I Could've Written a Better Movie Than That!* and *There's No Business Like Soul Business*, founder, ScriptwriterCentral.com

"Christopher Kenworthy's *Master Shots* provides an excellent breakdown of the underlying narrative structure of scenes. No matter how exciting car chases or fistfights may be, they are dramatically static until the audience knows the final result. Kenworthy shows us how to make these scenes work."
— Neill D. Hicks, author of *Screenwriting 101: The Essential Craft of Feature Film Writing*, *Writing the Action-Adventure Film: The Moment of Truth* and *Writing the Thriller Film: The Terror Within*

"*Sometimes one punch can tell the whole story....* Such begins one section in Kenworthy's vividly written, descriptive book. A winner."

> — Marisa D'Vari, author of *Creating Characters: Let Them Whisper Their Secrets*

"Kenworthy has captured the unwritten and visual language of the moving picture in this essential reference tool. Techies, directors and writers should read this book to practically and collectively harness this powerful language."

> — Deborah S. Patz, Executive in Charge of Production, *Magician's House*

"*Master Shots* gives every filmmaker out there the blow-by-blow set-up required to pull off even the most difficult of set-ups found, from indies to the big Hollywood blockbusters. It's like getting all of the magician's tricks in one book."

> — Devin Watson, producer, *The Cursed*

"Good books on film directing are rare, specifically books which focus on staging and framing challenging sequences like action scenes and chase scenes. In this engagingly written book, with helpful illustrations from actual films, Chris Kenworthy goes a long way toward bridging this knowledge gap. Essential for beginners or those looking for a refresher before (or during) their next film."

> — Christopher Riley, author of *The Hollywood Standard*

"*Master Shots* is not only a great how-to manual for budding directors, it's a terrific book for anyone who must communicate with directors or understand their language. Whether you're a director, writer, actor, designer, or producer, *Master Shots* helps you think about storytelling from the camera's perspective, making you a better filmmaker and collaborator no matter what your discipline."

> — Chad Gervich, TV writer/producer (*Reality Binge, Foody Call*) and author of *Small Screen, Big Picture: A Writer's Guide to the TV Business*

"THIS BOOK SHOULD BE BANNED! These are the really cool tricks and techniques of shooting professional directors keep secret just for themselves to use. Why should they be given away for a few dollars?"

> — John Badham, director (*Saturday Night Fever, WarGames*) and author of *I'll Be in My Trailer*

CHRISTOPHER KENWORTHY

MASTER SHOTS

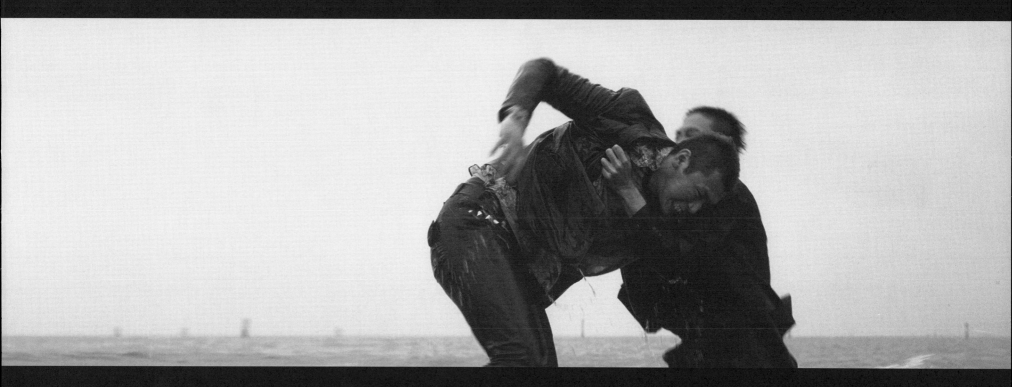

100 ADVANCED CAMERA TECHNIQUES TO GET AN EXPENSIVE LOOK ON YOUR LOW BUDGET MOVIE

MICHAEL WIESE PRODUCTIONS

Published by Michael Wiese Productions
12400 Ventura Blvd. #1111
Studio City, CA 91604
(818) 379-8799, (818) 986-3408 (FAX)
mw@mwp.com
www.mwp.com

Cover design by Johnny Ink. www.johnnyink.com
Interior design by William Morosi
Printed by McNaughton & Gunn

Library of Congress Cataloging-in-Publication Data

Kenworthy, Christopher.
Master shots : 100 advanced camera techniques to get an expensive look on your low-
budget movie / Christopher Kenworthy. -- 2nd ed.
 p. cm.
ISBN 978-1-61593-087-6
1. Cinematography. 2. Motion pictures--Production and direction. I. Title.
TR850.K46 2012
777--dc23
 2012002999

Printed on Recycled Stock

To Tabitha and Harriet

CONTENTS

INTRODUCTION

This book will give you the inspiration to execute complex and original shots, whatever your budget. I can say that with some confidence, because I receive letters and emails every day, telling me that *Master Shots* works.

When the first edition of this book was released, it rapidly became a best-seller, but far more exciting for me was to hear from filmmakers who were using the techniques. Seasoned Hollywood directors wrote to tell me that they were taking *Master Shots* on set with them every day. New directors told me how they'd discovered their style after one reading and gone on to win awards.

I'd always hoped the book would be more than a collection of interesting shots, and would help directors to find new ways of creating their own camera moves. That seems to have been the case. *Master Shots* has been translated into several languages and is used at film schools around the world.

Although I get the most feedback from directors, I also hear from actors, cinematographers, producers and writers who have used the book to create better work.

Such was the success of *Master Shots* that I went on to write *Master Shots, Volume 2: Dialogue*. While creating the second book I realized there were several ways that the original *Master Shots* could be improved. All the images have now been enhanced for greater printed clarity, with some replaced by new renderings, to ensure that each technique is absolutely clear. The text has also been lightly revised, based on feedback from readers, to clear up any potential ambiguities.

The examples shown are generally from feature films with big budgets and all the crew and equipment you can imagine. And yet every single shot in this book can be achieved on the cheap, with a handheld camera. That's why I don't waste any time suggesting what sort of dolly or crane you should use, because you may end up improvising. Many of the greats have done so before.

In TV, and even many films these days, people often move the camera just because they can. Or because people think a moving or wobbling camera is somehow more exciting. But skillful, motivated master shots and well-executed moves can make all the difference between shooting another journeyman scene, and capturing something truly great. Never move the camera for the sake of it, but never sit it on a tripod because you're too lazy to think of something more interesting. If you're stuck for ideas, look through this book, because somebody has almost certainly solved your problem once before. And you can probably improve on their solution.

In almost every chapter I talk about lens choice, and suggest what type of lens you should use for a particular shot. If you're not the sort of director who's interested in lens choice, I encourage you to get a basic grasp. Even if you consider yourself an "actors' director," remember that you can't do the actors' performances justice unless you know the best way to shoot them. It only takes an afternoon with a 35mm Digital SLR, or just using the zoom on a HI-DEF camera, to see what effect different lenses have. (Although a zoom is a single lens, you can think of it as many different lenses, ranging from short to long.)

Don't leave the lens choice to your Director of Photography. Although your DP can do the job for you, there's no way you can accurately plan your shots (or come up with them on set) unless you have an understanding of lenses. There are many books that explain the difference between lenses, and what they achieve, but there is no substitute for getting out there with a camera and having a go. If, in any given chapter, I suggest that a long lens works better, try it, and then try it with a short lens and see whether you think I was right or not. What you learn from that is more important than anything I could put in words.

This is not a book about lenses, but I know that a random lens choice leads to a random shot and a potentially meaningless scene. This book is about camera moves, and the master shots that make your scene work. For every scene you need to choreograph a dance between your actors and the camera, with the perfect lens choice. And that's before you even think about directing performance. There's a lot to keep in your head, which is why a book like this can help. The more techniques you know, the sooner you will be able to forget them and come up with your own.

The plans you make are only rough, but that gives you more chance to be creative on the day of the shoot. This book can help you to start planning your own shots, so that when you are on set with just a few moments to come up with a great idea, you'll know what to do.

I've been working in film and TV for over a decade now, but to my surprise, I've found this book an enormous help in planning shots, whenever I am on set. These observations and ideas give me a starting point. I can see how it's been done before, how it could be done again, and I can add new ideas as I go.

The techniques in this book cannot make you a good director, but by learning them you will gain great insight into what makes shots work. By the time you've learned everything in this book, you'll be able to make up another hundred of your own.

Christopher Kenworthy
Perth, June 2011

HOW TO USE THIS BOOK

You can dip into any chapter of *Master Shots* and look for a shot that best suits your scene at any time. I would recommend, however, that you read the whole book, so that you become familiar with the variety of techniques demonstrated.

Although watching the films used in this book may help, you should try to imagine the technique by looking at the frame grabs and the overhead diagrams first. This will help to develop your ability to visualize scenes. It's far more important for you to practice this skill than it is for you to see the films that have been used. With that said, all the films included in this book contain many shots that are worth studying.

To really understand a chapter you need to read the text, study the images, and imagine how you could use the shot yourself. So you should already have read *Master Shots* when your film is in preproduction.

Once you've planned your shots, have the book nearby on set, so that you can find alternative ideas, or add something extra to a scene. One of the best things you can do is combine several techniques in one scene, to create something completely new.

Don't be afraid to buy copies for your department heads and your actors. If they can see how you're working, and the high standards you're aiming for, they will be more willing to work with these techniques.

ABOUT THE IMAGES

Each chapter contains several types of images. The opening images are frame grabs from popular movies, to show how successfully the technique has been used before. For this second edition of *Master Shots*, these frame grabs have been enhanced in Photoshop CS5, to greatly improve their clarity when printed.

The overhead shots show how the camera and actors move to achieve this effect. The white arrows show camera movement. The black arrows show actor movement. For the second edition of the book, many of these shots have been clarified with minor changes, and in some cases 3D arrows have been added to give a more precise indication of motion.

The overhead shots were created using Poser 8, which enables you to animate characters while moving a virtual camera around them. The arrows were created in Illustrator and added in Photoshop.

The final frame in each chapter is a recreation of the scene rendered with computer graphics. These rendered frames are all subtly different from the movie frame grabs, showing that slight adjustments to your setup enhance and expand on the core techniques.

To create these simulated shots, Poser renderings were exported and then backgrounds were added. Some of the backgrounds are original photographs, and some are computer renderings. For this edition, new renderings were created for several chapters, to give a clearer indication of how the technique can be applied.

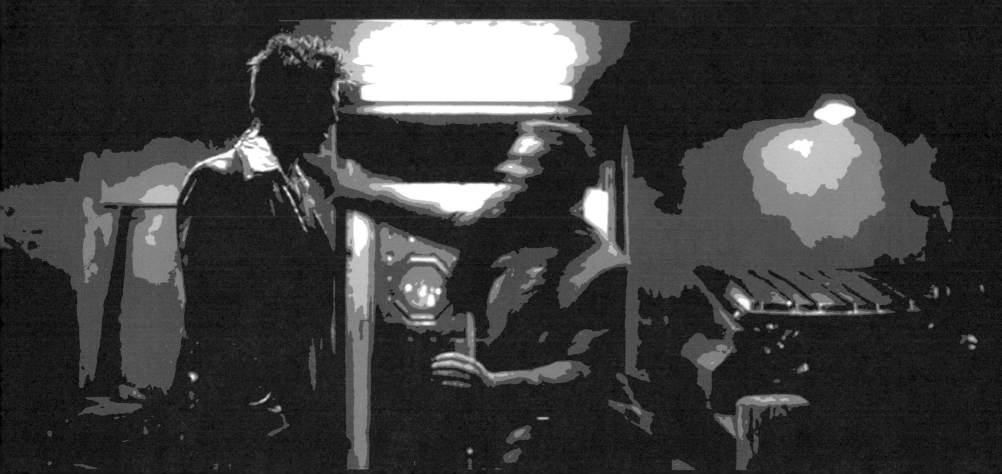

FIGHT SCENES

LONG LENS STUNT

The most basic approach to shooting a violent punch is one of the most effective. The very first punch thrown in *Fight Club* was shot this way, and it's used again throughout the film, so it can't be bad.

Most actors are willing and able to pull off this stunt, because it doesn't require a great deal of skill, except in terms of timing. It's a performance challenge that most actors relish. The basic technique is nothing more than having one actor punch to the far side of the second actor's head. Although most filmmakers can guess the basic technique, many forget the importance of lens choice. If you shoot this with the wrong lens, it looks ludicrous and the illusion fails.

The secret is to use a long lens. When you shoot with a long lens, distances between objects are artificially foreshortened. In *Fight Club*, you can see that the long lens makes the distant wall look close to the actors, even though it's a good distance away. This foreshortening also applies to the actors. Edward Norton punches to one side of Brad Pitt's head, but it looks as though he makes contact. The illusion is sold so well because Pitt reacts at the exact moment of supposed contact.

Set up your camera with a long lens, and then frame the actors as required. The framing used here is only an example, and the technique works well with tight or wide framings.

Position your camera so that when the punch lands, the fist is hidden behind the victim's head. Actors may be tempted to punch quite close to each other, as they are determined to achieve realism, but this isn't required. Assure them that the punch can miss by a good few inches and still look real. Run the scene in slow motion, and check the shot in camera or on a monitor, to ensure that this is the case. The fist can even go in front of the face being punched, so long as the victim's head is thrown back convincingly.

It's fine to include some camera movement to follow the action, so long as the punch itself is hidden behind the actor's head. You can shoot an entire sequence this way, with careful planning and rehearsal.

Fight Club. Directed by David Fincher. Twentieth Century Fox Home Entertainment, 1999. All Rights Reserved.

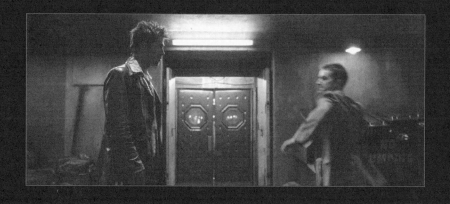

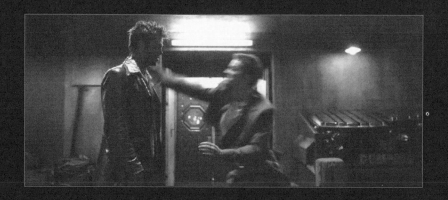

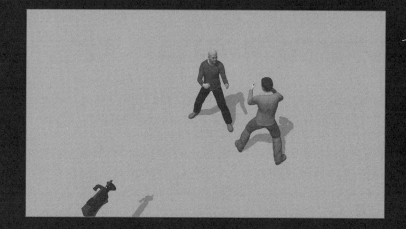

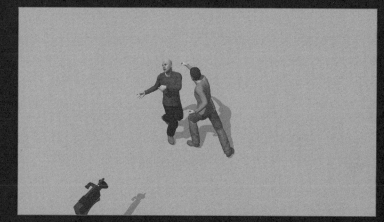

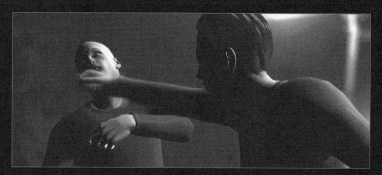

SPEED PUNCH

Sometimes one punch can tell the whole story. Your hero makes one huge, sweeping punch, and the victim is knocked to the ground. There's no ongoing fistfight, no battle for victory. It's all over in an instant.

If your story requires this sort of rapid fight, you need to create the impression that this is the most perfect and forceful punch that's ever been thrown. Using a similar technique to that seen in Long Lens Stunt, your hero should punch behind the victim's head. The difference here is that the camera's motion will be directly connected to the actor's momentum, and will echo the feeling of the punch.

Set up your camera alongside the victim, looking toward the hero. If you're using a long lens you may have to get quite close to the actor playing the victim, to see both characters in shot at the same time. Avoid getting so close that this becomes an over-the-shoulder shot from behind the victim character, or that the audience can feel like the victim of the attack, rather than cheering the hero on. The hero should be the focus of the shot, so a central framing as he attacks works well.

As your hero approaches the victim — with a run, lunge, or determined walk — the camera should move backward slightly, as though pushed by his movement.

Then, when the punch lands, the camera comes to a standstill, but pans in the direction of the punch. It's as though the punch has also hit the camera and knocked it to the side. This will have the effect of putting your hero, and the victim, to the left of frame. It takes good timing on the part of your camera operator, but when executed well, it can make the safest of stunts look like an extremely powerful attack.

Punch Drunk Love. Directed by Paul Thomas Anderson. Columbia Tristar Home Entertainment, 2002. All Rights Reserved.

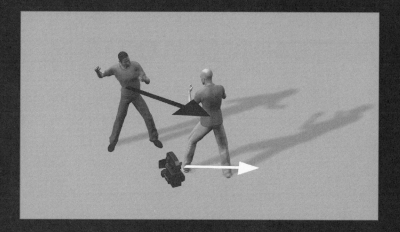

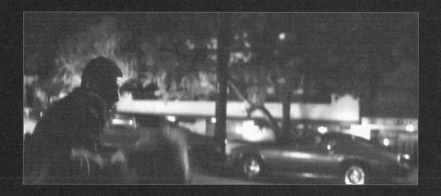

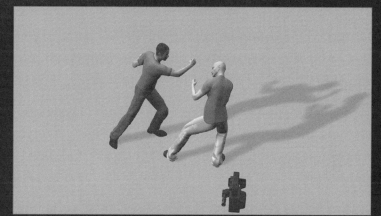

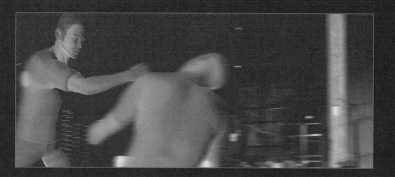

MATCHING MOTION

The traditional movie fist fight, where opponents stand opposite each other laying punches to the face, looks a little dated. You still see it, of course, but if the nature of the fight is important to your story, or if you want the audience to really concentrate on who is winning and what's going on, you need to be more inventive. You need to make the audience feel as though they are really there, watching the painful and dangerous action.

One way to do this is to let the camera's motion be dictated by the movement of the actors. So, as the actors move, the camera moves with them. This works best when the actors are brawling and dragging each other around. As such, it may come later on in a fight, when the characters are tired and struggling.

Set up your camera alongside the actors, at about head height. During their struggle, one actor should drag or push the other actor across the room. Your camera should move with the actors as they go. To get the strongest feeling of movement, don't change the camera's height, pan angle or distance from the actors as you move.

When actors move as a pair, their pace will never be completely even. As such, it's easy to fall into the trap of following the two of them as a combined unit, to keep everything in shot. This has the effect of reducing the sense of motion. Instead, focus your camera's attention on one actor, rather than the two as a pair. The difference is subtle, but it is important.

As the actors come to a stop, hitting a wall or falling down, you can then change pan angle, camera height or distance, as this emphasizes that their motion has come to an abrupt end.

Fight Club. Directed by David Fincher. Twentieth Century Fox Home Entertainment, 1999. All Rights Reserved.

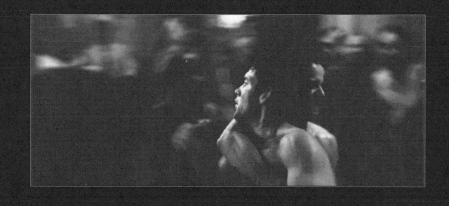

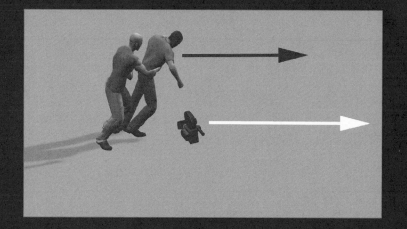

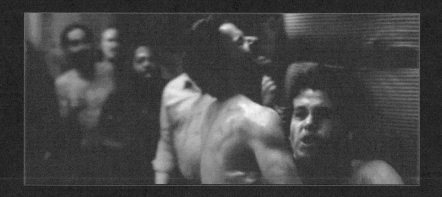

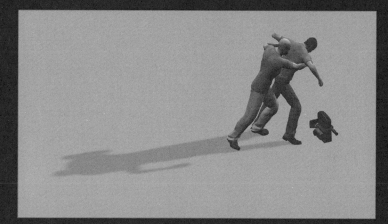

KNOCK DOWN

Having your character knocked to the ground is a powerful storytelling moment. It tells the audience that things are not going well for the character, and that the fight is being lost. On set, though, this can mean putting your actor in danger, or spending money on a stunt person.

A cheap alternative is to show your actor being punched, then cut to a close-up of the ground as your actor goes down. This tends to feel staged, however, and doesn't have the power of a single shot, taken without cuts.

The solution is to combine the Long Lens Stunt with a simple camera move, which hides your actor's gentle movement to the ground. Rather than having your actor fall dangerously to the ground, you can disguise a gentle sit-down on to the floor and make it look like a dramatic moment.

These stills from *Patriot Games* illustrate the point. Harrison Ford fakes being punched, while the camera remains at head-level. He then gently sits back onto the ground. Once he's dropped out of sight, the camera moves down to the ground, where Ford acts as though he's just hit the ground hard. It's extremely simple misdirection, but with the right timing and use of sound it looks completely convincing.

Set your camera up at eye level, behind the attacker. As the punch is faked, the victim fakes being punched and lowers gently to the ground and lies down. At the same time, the camera drops down to the victim's eye level, with the attacker shielding the victim's movement from view. It helps if the attacker continues to make aggressive movements toward the victim during this camera move, so the audience has something to watch other than the camera move itself.

Patriot Games. Directed by Phillip Noyce. Paramount Home Entertainment, 1992. All Rights Reserved.

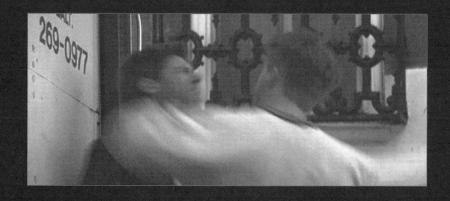

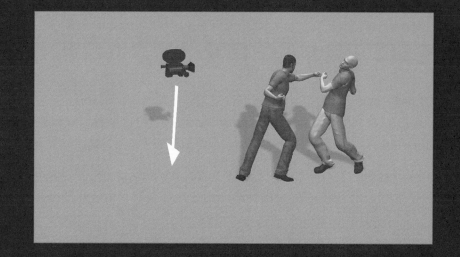

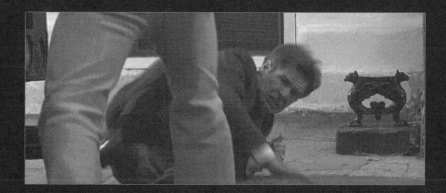

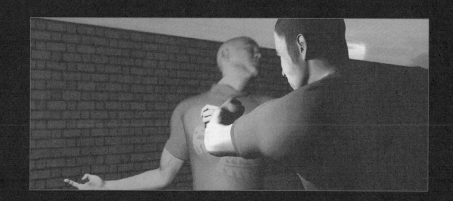

CUTTING FOR IMPACT

In real fights, feet are used as much as hands. In films, kicks can be used throughout a fight, but are especially useful when showing the build-up to a defeat. One character is on the ground, and the other is kicking. This can even occur after the main fight is over, and the winner is enjoying the victory.

How do you shoot this type of kick, without getting involved in complex stunt work? The best way is to shoot with the edit in mind from the outset, getting coverage that will enable the editor to make the kick look effective. You cut from the shot of the attacker to the shot of the victim, at the exact moment of impact. By planning for this edit, you can get a better result than trying to show the entire kick-and-reaction in a single shot.

To emphasize that one character has the upper hand, everything should be shot from down low. Point your camera up at the aggressor, who can kick something soft that's out of shot. Don't have your actor kick thin air, as that looks fake. Always put a mattress or some padding in there, to give your actor something to work with. Your camera should be quite close to the actor, so that the audience really feels the kicks.

For the second shot, again position your camera low to the ground, some distance back from the victim of the kicks. Use a long lens, which shortens apparent distance between aggressor and victim. On action, the aggressor should simulate the end of a kick by pulling his foot upward or backward. At the same moment, the victim should recoil, as though the kick has landed. By itself, this will look terribly fake, but with sharp editing and sound, it will convince.

When it comes to editing, let the first shot of the attacker's face run for one or two kicks (to give the audience the idea what's happening), then at the moment of the third impact, cut to the lower shot and see the victim's reaction.

Superman Returns. Directed by Bryan Singer. Warner Home Video, 2006. All Rights Reserved.

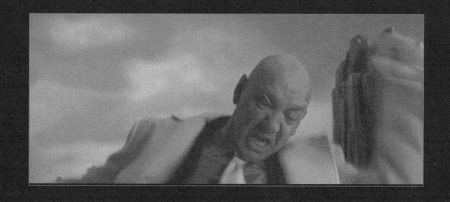

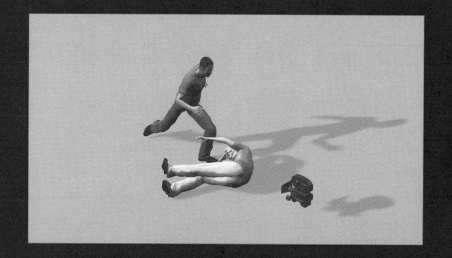

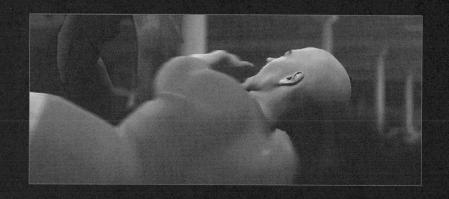

DOWN ON THE FLOOR

In reality, most fights end up on the floor in moments. In film, it usually takes a while longer, but characters who fight usually end up scrabbling on the floor after the real punching has been done. Partly this is cliché at work, but it also reflects the paradoxical intimacy of a fight. It shows that your characters aren't just thumping each other for the sake of violence, but are involved in a confrontation as personal as a loving embrace.

When your characters end up on the floor, the imbalance of power is more obvious. After all, somebody is on top. The same person may not stay on top for long, of course. Most fights usually end on the floor, because you can see whether one person wins, or whether a truce is reached.

It's simple to shoot toward the ground, over the shoulder of the character who's uppermost, but a little more effort is required to see this uppermost character's face in the reverse shot. Placing the camera on the floor, even without a tripod, will put it too close to the actor's face. You could opt to widen the lens to compensate, but lens choices should be dictated by you, rather than by the constraints of the location.

The solution is to raise the actors onto a platform or table, so the camera can be placed below them. This lets us see the uppermost character's face, and share in the second character's feeling of defeat. In both shots, use the same lens, and keep the camera the same distance from the face that's in shot.

It goes without saying that great care should be taken, and that padding should be placed around the table. Don't have your actors carrying out complex choreography on the raised table; save these close-ups for the point where the fight is coming to an end.

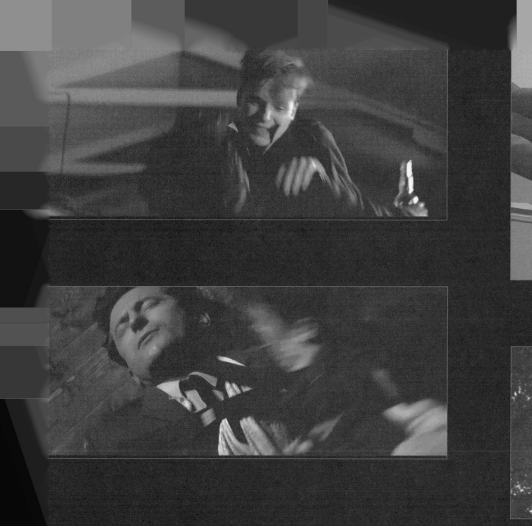
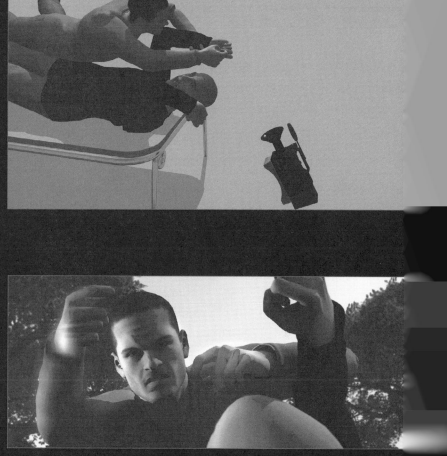

OFF-SCREEN VIOLENCE

If you want to show a violent attack, but don't want your film to descend into a gore movie, you might not want to see blood and suffering on screen. Sometimes, your film requires a strong implication of violence, without actually seeing the impacts that are taking place.

These frames from *Sideways* show one character beating another with a motorcycle helmet. She repeatedly hits him in the face with the helmet, breaking up his face. It's vital for the story that we sense the extreme nature of her anger and violence, but as this is more of a comedy than a thriller, it would be completely wrong to see his face being smashed to pieces. The solution is to show her attack, but not its result.

This technique enables you to create the effect of a violent attack without great risk to your actors. Set up your camera at about waist height, looking up at the attacker, who simulates repeated blows to somebody who is on the ground.

It works best if we see the victim upright in the shot, before the attack begins, so use one of the other techniques in this chapter to introduce the victim and get them on the ground, and then continue with this shot. The actor playing the victim should, of course, roll out of the way and be replaced with some padding, so that the attacker has something to actually hit.

The real strength of this technique is that it requires no cuts, and allows a direct view of the attacker's face. It reveals far more energy and character than a sequence that relies on stunts and cuts.

Sideways. Directed by Alexander Payne. Twentieth Century Fox Home Entertainment, 2004. All Rights Reserved.

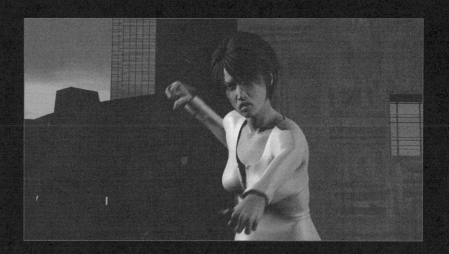

THE MOMENT OF DEFEAT

When a fight comes to an end, you want it to be very clear who's won and you also need to see the effect this has on both characters. In film, this usually means that the victor sits atop the loser and either knocks him out or kills him, but before that moment, it's important to relish the moment of victory.

As these stills from *Patriot Games* show, the choice of lighting and lens are completely different for each actor. The victor is shown sitting atop the loser, and we see his expression and read what's going on in the depths of his character. The victim, meanwhile, is shot in an almost surreal light, with a long lens, from the point of view of the victor. The contrast in styles shows the contrast in their predicaments.

At the very end, the loser falls back out of sight, leaving Harrison Ford alone in the frame. This is important, because it signals that the fight is over, and allows the audience to refocus on the hero of the story, and watch the emotions play out.

The first set-up, showing both actors, can be the same as Down on the Floor, or you can simply shoot from ground level, with the camera off to one side. The second set-up can be shot with a long lens, high above the actor, or a short lens, with the camera close to the actor. Each will give a different effect, and the choice depends on the requirements of your particular story.

Patriot Games. Directed by Phillip Noyce. Paramount Home Entertainment, 1992. All Rights Reserved.

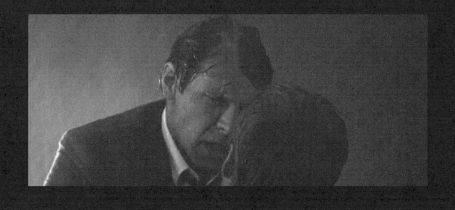

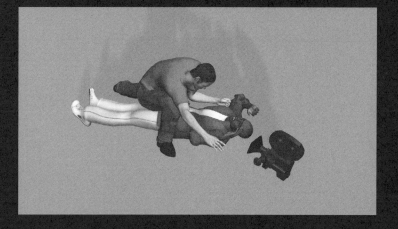

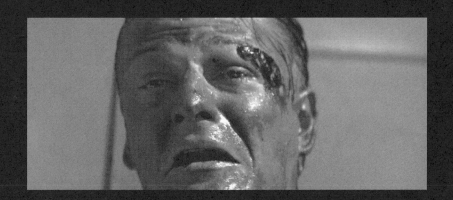

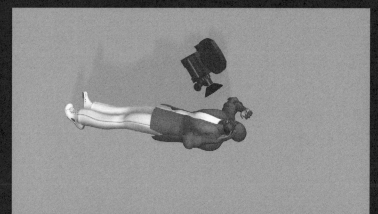

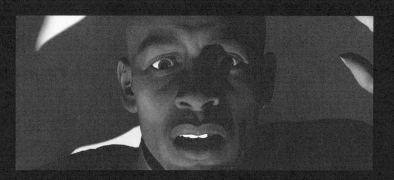

CHASE
SCENES

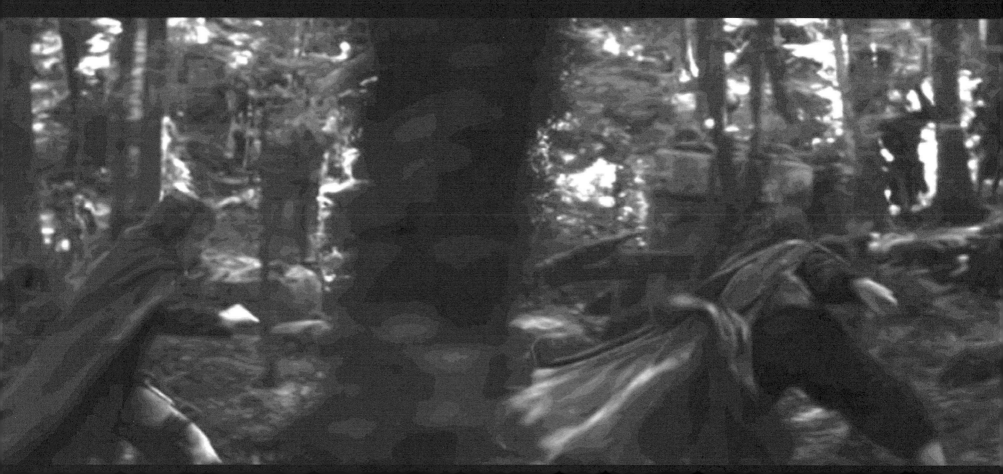

TRAVEL WITH SUBJECT

When somebody is being chased, you don't even need to see the person who's chasing them for the scene to work. In fact, seeing nothing other than empty space behind your actor is more terrifying than watching somebody approach.

A shot such as this only works once the chase has been established, because we need to know that the character is being pursued. It works best when the actor is struggling through difficult terrain that involves climbing hills and changing direction. If you shoot at night, make sure that enough of the background is lit up sufficiently for the audience to feel this sense of movement.

Set up your camera quite close to the actor, but with a short lens. This accentuates the sense of movement, but exaggerates the background space around your actor. You should keep the camera the same distance from the actor during the shot so the audience feels a strong affinity to her movement.

In these examples, the actor is centrally framed. You don't have to use central framing, but whatever framing you use, keep it exactly the same through the shot. This persistence of framing means the camera is locked onto the actor's movement, so we feel her struggle. The more changes of direction there are during the shot, the better it works. A windy path up a hill is perfect, as it includes the struggle up the hill, as well as many changes of direction.

You need never see the attacker in the background, although this shot can easily be adapted to include the attacker appearing at the very end of the shot. You create far more suspense if the escapee does not see the attacker appear in the background.

Friday the 13th Part II. Directed by Steve Miner. Paramount Home Entertainment, 1981. All Rights Reserved.

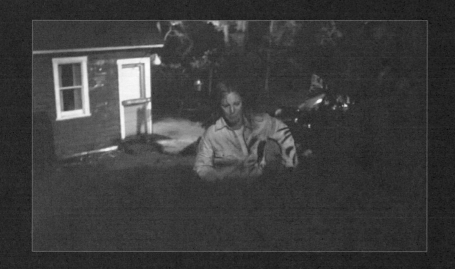

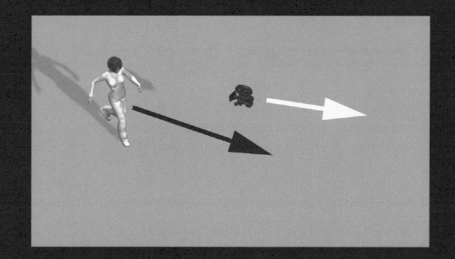

LONG LENS PAN

Most chases involve one person running away, and another following them. You can create a far more original sense of fear if you have your character run across the screen while the attacker runs straight toward camera. This won't work in all story situations, but if your main character has a definite goal that must be headed toward, and the attacker can come at them from the side, it's great imagery.

A long lens is used because as you pan with your actors running left to right across the screen, the sense of movement through the environment is greatly enhanced. This works best if there are trees or other obstacles around them and in front of them, flashing across the screen. Equally, the long lens foreshortens the distances, so the attackers appear to be horribly close, even though they are quite distant.

Set up your escaping actors and their path first, then set up the attackers and camera at equal distances on either side of them. You can track along with the actors on a dolly, but if you're using a very long lens, there's really no need, and a pan creates just as powerful an effect with a lot less effort.

The effect only works if the attackers can be clearly seen. In this shot from *The Lord of the Rings: The Fellowship of the Ring*, the scene is very busy, with lots of trees and terrain, so it only works because there are many attackers in the background. If you only have one attacker, the scene should be set in a much quieter environment, so that the attacker is immediately visible.

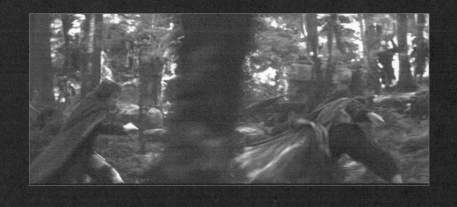

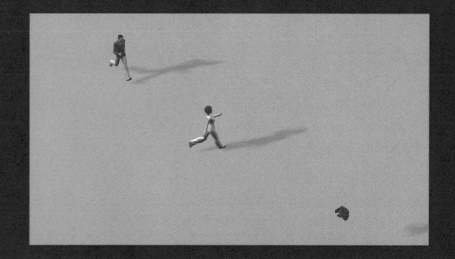

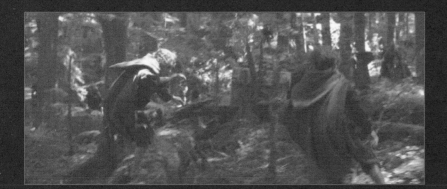

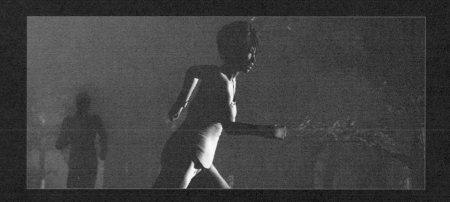

PASSING THROUGH TIGHT SPACES

When somebody is being chased, you can raise the tension by having them pass through a tight space. When space begins to run out, it indicates to the audience that the scene is about to reach a conclusion, and that the pursuers are going to catch up.

To shoot this you'll need a location (or set) that is genuinely narrow. Use a short lens, to exaggerate the character's apparent movement toward you. Although short lenses can make tight spaces look bigger (which *isn't* what you want), a short lens also shows more of a location and exaggerates character motion. In other words, the short lens fills the screen with more wall, and makes the character rush artificially fast toward the camera. This combination of effects makes it look as though the character is moving into a tight space.

To get this to work well you need to position your camera in the middle of the alleyway, so that it's in the way of your character's intended path. As your character is just about to hit the camera, track away from this path, and pan to follow him as he looks back over his shoulder. You can keep the camera low, looking up at the character, to really emphasize that he's moved into a tighter, darker space. Let the camera come to rest as the character runs out of the shot.

With a slight variation, this shot can have the exact opposite effect. You can show your character looking back, seeing that the pursuers are no longer following, and then pan as he passes the camera and follow him as he runs off into the distance. This indicates that the chase is over, and that he got away.

Minority Report. Directed by Steven Spielberg. Twentieth Century Fox Home Entertainment, 2002. All Rights Reserved.

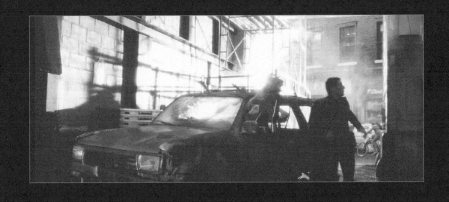

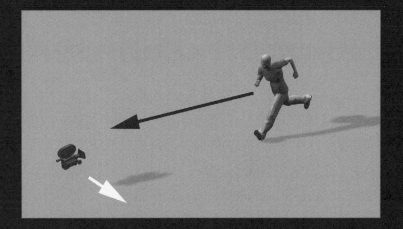

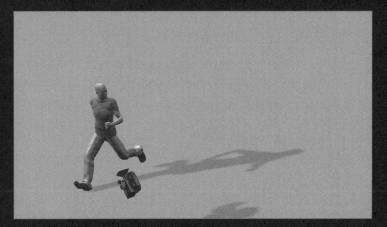

THROUGH OPEN SPACES

During any chase scene, it's wise to give your hero a goal at some point. There should be a house, doorway or car that he is trying to reach. At this moment the audience becomes even more tense. When the destination is within sight, the thought of being caught is unbearable.

If you want the attacker to actually catch up during the scene, that's easy — you just film him catching up. But if you want to film the scene with no change in distance between the two characters as they head toward the goal, how do you make it scary? The danger is that it will just look like they are both plodding along with no real sense of urgency. The secret is to shoot this with two cameras moving across the set at different speeds. You can create an optical illusion that makes it feel as though the hero is going to lose, without actually having the attacker catch up.

To the audience, it simply looks as though the hero is trying to get away, and the attacker is in hot pursuit. It doesn't look as though the attacker is actually catching up, but it *feels* as though he is catching up. This is a very subtle difference, but one that can make all the difference to your story.

The frames from *Hide and Seek* show how a potentially dull chase can be made terrifying. As Robert De Niro runs toward his house, the camera following him catches up quickly. This creates the sensation that he's being caught.

The camera that faces the attacker moves backward slowly, while the attacker runs toward it at great speed. This creates the feeling of being caught. It's vital that this camera moves backward, so the audience feels as though they are trying to avoid being caught.

When you shoot the hero, a longer lens can enhance the nightmare effect; it makes the goal look closer, but the goal doesn't get much closer no matter how fast he runs. A shorter lens on the second camera makes the attacker's speed seem almost superhuman as he approaches.

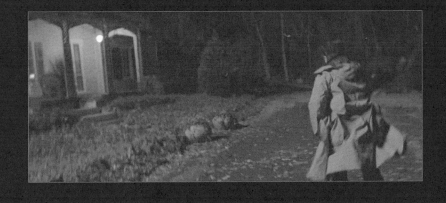

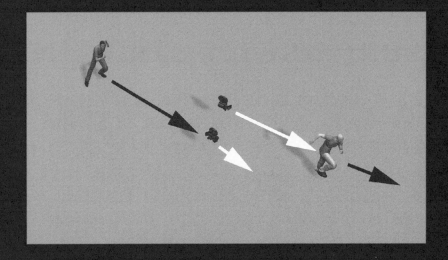

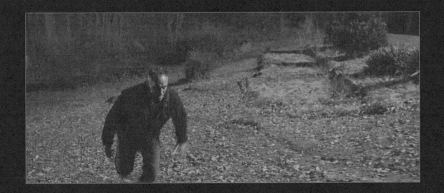

SURPRISES ALONG THE WAY

Chase scenes work well when you allow for a few moments of suspense, rather than making every moment a breathless pursuit. You can create suspense either by seeing something in the background that the character can't see, or by having the character see something before we do.

These frames from *Behind Enemy Lines* show the hero having stopped along the way, believing he's got far enough away from the enemy that's pursuing him. If the camera was at his head height, we would see the enemy walking behind him, and this would create one kind of suspense. But for more of a shock factor, to jolt the audience out of this moment of calm, the camera is kept low. Then, when the hero hears something, he turns away from the camera. For a few moments we have no idea what he's looking at. This creates a moment of suspense for the audience, which leads to fear. We then cut to a long-lens shot of the enemy walking through the woods.

To create this effect you need to set up the camera below head height looking up at the actor. It's ideal if there's some sort of barrier for him to be leaning against, as this creates a shield between him and the enemy, making it plausible for him to be unseen.

At the moment the actor hears the enemy, have him look around. Take a moment to watch his reaction, before cutting to the shot from his point of view. This keeps the enemy unseen, just for a moment, and it's this anticipation that makes the audience feel a sense of fear. When the enemy is revealed, we know the chase is on again.

Behind Enemy Lines. Directed by John Moore. Twentieth Century Fox Home Entertainment, 2001. All Rights Reserved.

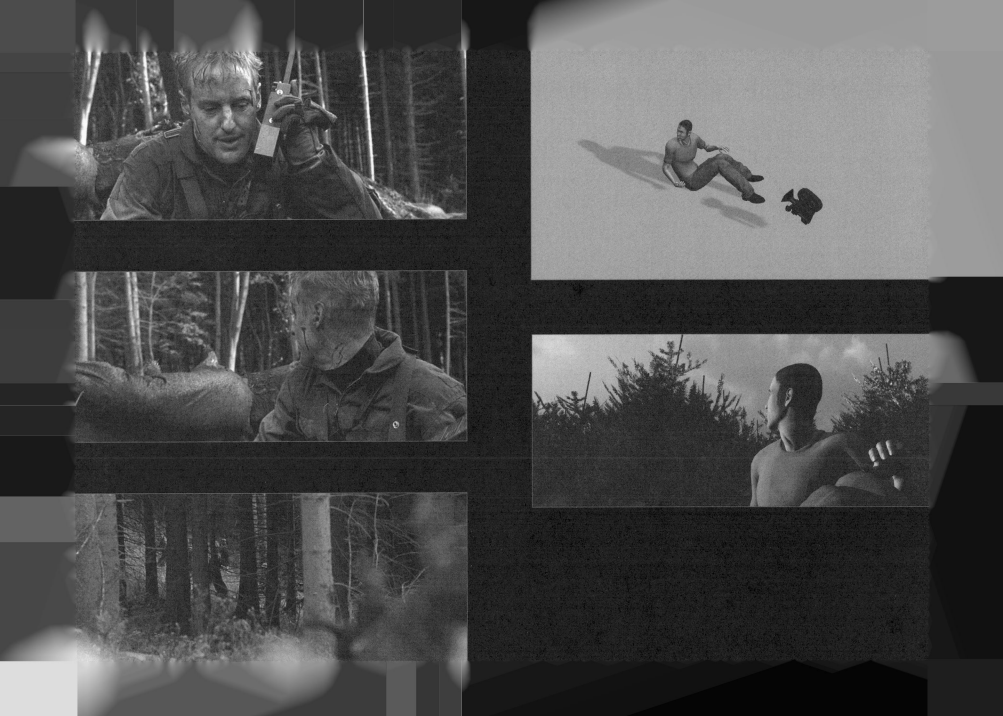

THE UNSEEN ATTACKER

It's often said that the unseen is far more frightening than what is seen. To take advantage of this, however, you need to make it clear to the audience that something or somebody is actually there, chasing the victim. An effective way to do this is with sound. In this example from *An American Werewolf in London*, the victim is walking alone in the underground station when he hears wolf noises. The first few shots show him listening and peering around, with nothing being seen. Only vague sounds are heard.

Then, when the werewolf appears, rather than seeing the wolf, we see everything from the wolf's point of view. Best of all, the camera creeps around the corner, with the victim gradually coming into view. This makes it feel like we, the audience, are creeping up on our prey. If the scene began this way, we'd have no sympathy for the victim, but as we've seen him afraid, and looking around for the werewolf, this shot works extremely well.

To use this effect, make sure you show your hero or victim listening, and peering around for the unseen attacker for some time. Then, set up your camera, low to the ground, and around the corner from the victim. Use a short lens, to make the victim seem a long way away. The short lens also means that as you turn the corner and advance toward him, the camera's movement appears to be much faster than his attempted escape.

You can carry this principle to its extreme by not showing the attacker until the very last moment.

An American Werewolf in London. Directed by John Landis. Universal Studios Home Video, 1981. All Rights Reserved.

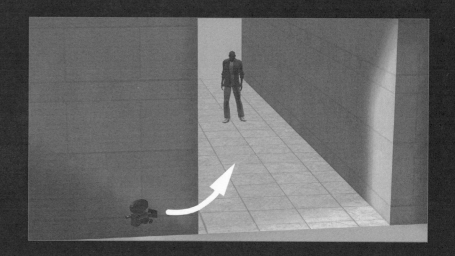

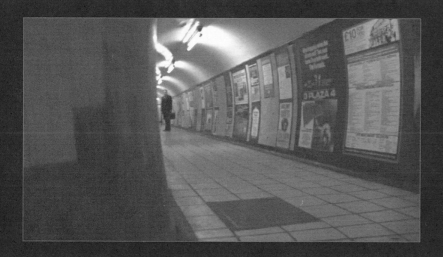

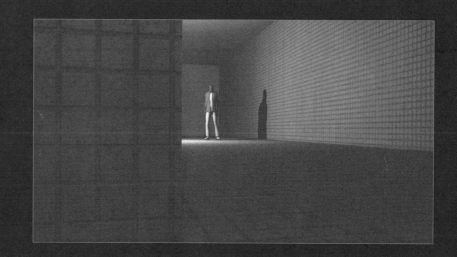

THE CLOSING ATTACKER

There are many conventions in cinema, and sometimes you can create a powerful effect by breaking them. One convention during a chase scene is to follow the escaping victim from the point of view of the attacker, getting closer and closer. A slight adaptation to this shot creates a great moment of shock.

In the frames from *Murder By Numbers*, the hero is trying to escape, and the camera is chasing. The audience expects this to continue until she reaches a door or trips up, or some other cliché. Instead, the attacker moves into shot and grabs her. What we thought was a Point of View shot was nothing of the sort – we were running alongside the attacker, and he suddenly made a gain on us. This is guaranteed to make an audience jump, as it breaks expectation.

Set up your camera with a short lens, just behind the character that's escaping, and give chase. It helps if you give your character a goal to be aiming for – a door or corner. This gives the audience something to hope for. They hope your character will make it that far before the camera catches up. During the take, your camera should catch up slightly, but before you get there, have the second actor speed up and move into shot, making a grab for the victim.

This works best if you don't give the audience time to guess what you're about to do, so the whole shot only needs to be a few seconds long. It works best if there is a desperate sense of urgency, with the victim scrambling and falling and trying to keep going through difficult terrain.

Murder By Numbers. Directed by Barbet Schroeder. Warner Home Video, 2002. All Rights Reserved.

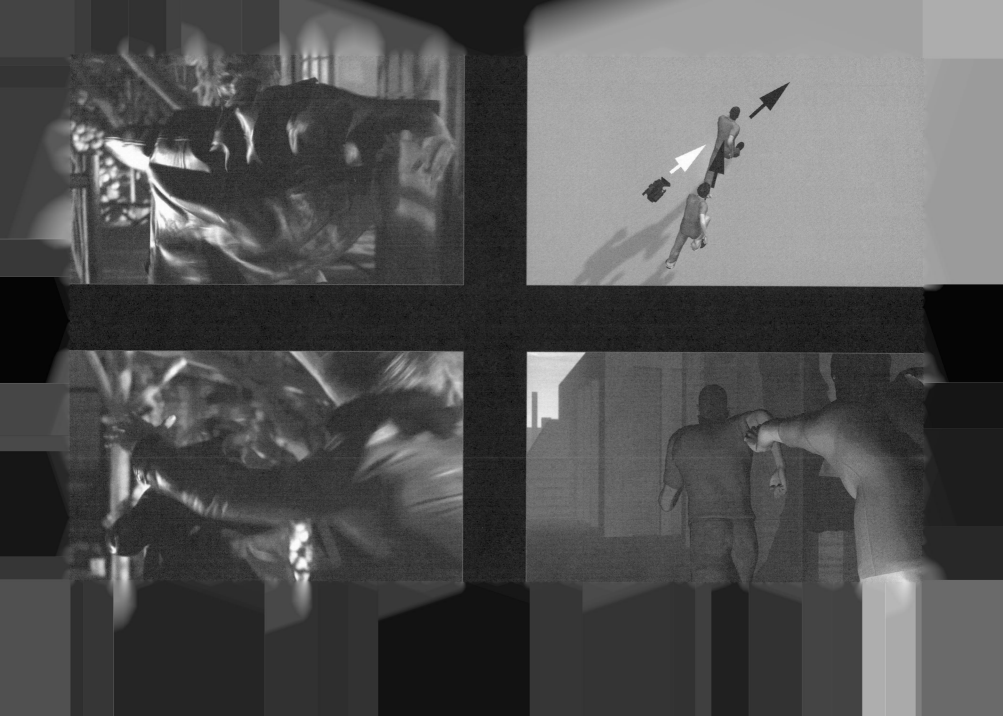

UNFAIR SPEED GAIN

Not all chase scenes are a mad rush, with one character chasing another. Sometimes your hero is simply trying to hide, hoping the attacker won't find him. When this is the case, you create a jolt of fear in the audience, when the attacker makes a sudden gain on the character.

In reality, this could never happen, but with careful shooting and editing, you can make it look as though your hero's slight hesitation has given the attacker the chance to make great progress in his pursuit.

The frames from *Blue Velvet* show how Dennis Hopper approaches the building, walking (but not running) across the street, and moving briefly out of sight. We then see Kyle MacLachlan looking down, pausing as he decides what to do. A moment later, we look down again from MacLachlan's point of view, and see Hopper much closer than should be possible. It's a frightening moment and one that means the full chase is on, and MacLachlan's character has to run and hide. It makes an ordinary man seem much more frightening.

To make this effect work, you must have the attacker disappear briefly behind a wall, stairwell, or other object, and then cut back to the observing hero. The third shot should be taken with a much longer lens. This not only increases the apparent gain the attacker has made, but also echoes the tunnel-vision effect that occurs in the real world when you see something truly frightening.

In the *Blue Velvet* example, MacLachlan is looking down, but you can easily shoot on the level or looking upward, so long as the attacker disappears briefly. Although you can have the attacker running, there is something far more sinister about somebody who's walking making a sudden gain.

Blue Velvet. Directed by David Lynch. MGM Home Entertainment, 1986. All Rights Reserved.

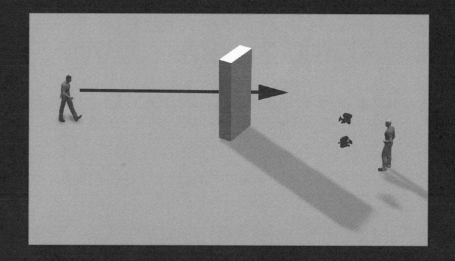

ALMOST THERE

The sensation of almost getting away, but suddenly being trapped, is frightening. In film this works best when there's a lot at stake. Use this technique when getting caught would mean instant death or the failure of a quest.

The frames from *Children of Men* show how three characters are running down a corridor, to get away from a man they've just beaten to the ground. As they run toward a jammed door, and struggle to get out, the camera chases up to them and catches up.

This is crosscut with a camera watching the fallen attacker get up. This camera moves slowly backward. The combination of two cameras moving toward the characters at the jammed door creates a great sense of urgency. In this example, the attacker isn't even coming toward them, but is merely getting up. The effect can be even stronger when the attacker is in actual pursuit.

When you set up this shot, give your characters an obstacle that is potentially impossible to pass, such as a locked or jammed door. That gives the first camera time to rush up to them. The other camera, which moves slowly backward, does not need to show the attacker in great clarity. The attacker can be on the ground, or distant, and the effect is still extremely powerful.

You can also use a mix of handheld camera and dolly work, which enhances the nightmarish quality of the moment. The camera that chases your characters can be handheld, while the camera tracking away from the attacker can move on a dolly. This mix of panicked camerawork, with something slow and steady, makes it feel as though the attacker is getting the upper hand, and will catch them no matter what.

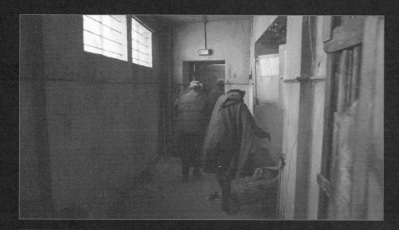

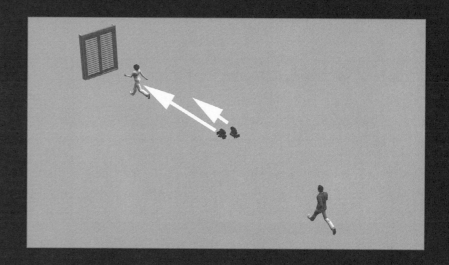

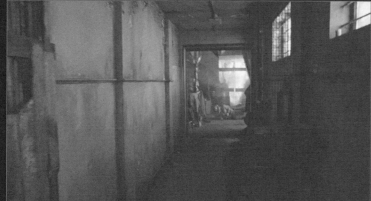

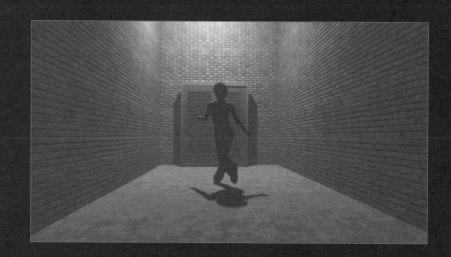

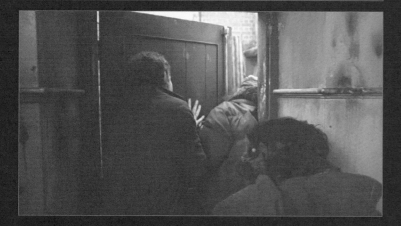

FOOTWORK

Chase scenes aren't always about an attacker and a victim. Sometimes you have one character trying to catch up with another for more innocent reasons. For this to work, it's best if the person being pursued has no idea a chase is on.

In this scene from *Amélie*, the male character is in a rush, and Audrey Tatou is trying to catch up with him. By putting the camera low down and shooting her feet, we get to see the energy of her pursuit, as well as how close or distant she is from the hero. This is much smoother than if we were watching this from over her shoulder, or from a wide shot.

Set up your camera slightly behind the character who's in pursuit. The other character should be slightly offset to the right, rather than directly in front. This makes it easier to get everybody in shot. The character who's in pursuit should run directly ahead on her own path, rather than toward the character she's pursuing. This enables you to move the camera slightly faster than her, pan on to her legs, and still keep the other character in shot.

The effect of being low-down, with this sort of smooth motion, is that the audience is forced to guess the character's emotion, purely through their movement and distance from each other. It must, therefore, come in the middle of other shots that have established the nature of the chase.

It's easy to pull this off with a handheld camera as you run, or with dolly tracks. You can even adapt this shot to include changes of direction, as well as going up or down inclines. Don't stay in this shot for too long, though, or the audience may become frustrated.

Although it is used here for whimsical reasons, it can also be used effectively in a more serious shot, where one person is secretly pursuing another.

Amélie. Directed by Jean-Pierre Jeunet. Becker Entertainment, 2001. All Rights Reserved.

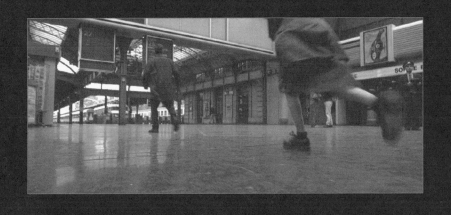

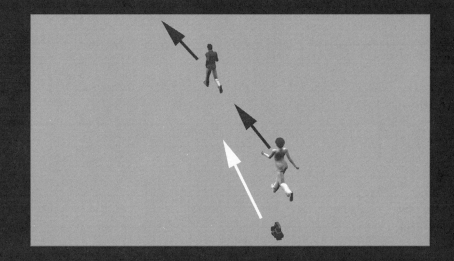

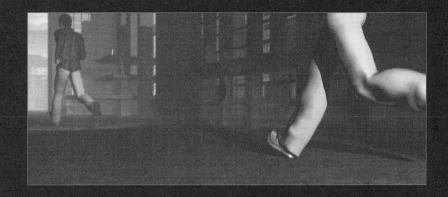

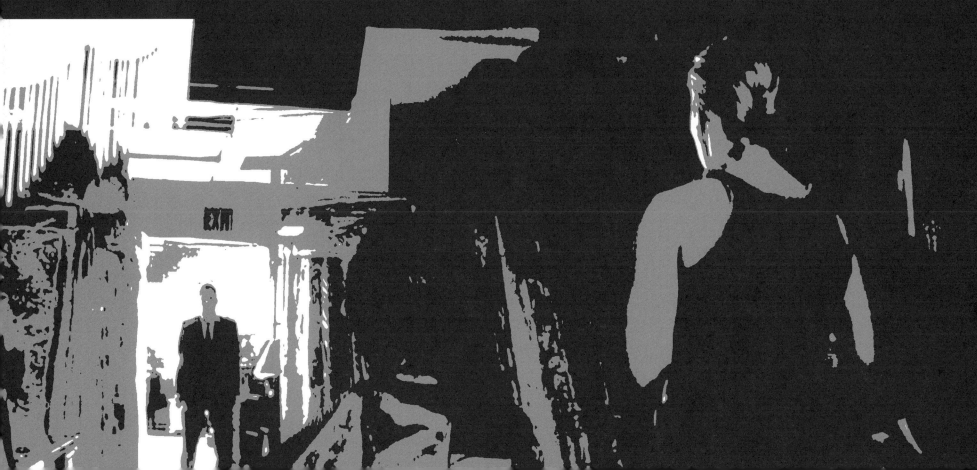

CHAPTER 3
ENTRANCES & EXITS

CHARACTER SWITCH

A powerful way to introduce your main character into the film is to show a crowd, and then have your character come to the front of the crowd and become the focus of the shot. This underlines that this character is a hero, and more important or interesting than everybody else in his world.

These frames from *Children of Men* show exactly how this works, because when this scene opens, we think we're just watching people observing a television set. We don't expect Clive Owen to push through to the front. When he does, and looms into view, it's clear that he's made an entrance to the film.

There are several ways to make your character stand out at this point. One is to give him more light than the other people in the scene. Another is to make sure that everybody who's on the same visual plane as him is shorter. The *Children of Men* shots show this well. Everybody else on the front row is relatively short, so he towers above them, making it clear he's the hero of the piece.

Set up your camera to the height of your main character, and angle down toward the crowd. Make sure there are no faces among the extras that are too distinctive or distracting, or extras that are trying to steal the scene by overacting. The extras should keep quite still as your hero pushes through the crowd.

This technique also underlines that your hero is an active character, somebody who will do things to the world, rather than have the world just happen to him. While everybody else stands there observing, he moves in and out of the scene. To the audience, this signals that we've met a character who's going to take action throughout the film.

Children of Men. Directed by Alfonso Cuarón. Universal Studios Home Video, 2006. All Rights Reserved.

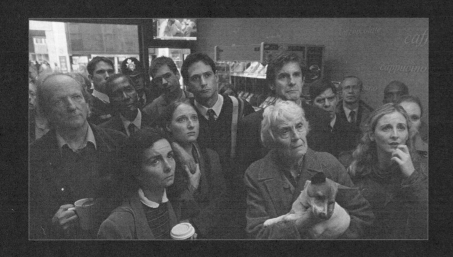

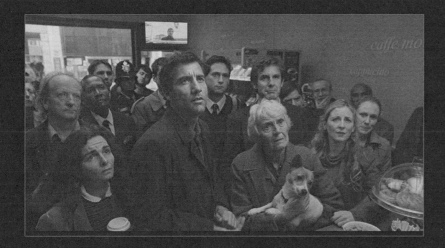

BACKGROUND REVEAL

Directors like to give characters strong entrances when they first appear in a film, and at key moments of change or drama. Usually, these entrances end with a close-up of the actor in question. You can take the opposite approach, and show the character in the distant background. This works best when the character's appearance in a scene is a surprise, either to the audience or the other characters. It works better for entrances that occur when we already know the characters well.

In this example, from *Punch Drunk Love*, the scene starts with a set-up that appears to be nothing more interesting than two characters bickering during a haircut, but then as we move around them, we see that Adam Sandler is watching them. He doesn't actually make an entrance. Instead, the camera gives him an entrance through its movement. His lack of motion makes this dramatic.

The effect is lost if you announce the character's arrival with a loud bang, a shout, or some other call to attention. Although a minor sound can be used to attract the other characters' attention, let the visuals do the work. Set up the opening of the shot as though a full scene could be played without a camera move. The entrance of the third character should feel like an intrusion on the scene.

Although you want the entrance to be a surprise, you don't want the camera move to feel forced. Set up your shot so that there's some empty space at the side of the frame. Once the shot's begun, your camera can move toward this empty space, keeping your characters roughly in the middle of the shot.

Although you can get the required result with a simple track and pan, you create a stronger effect by circling slightly around your characters, as you pan toward them. The shot can end with the hero to the left of frame (and the left of the other two characters), or framed between them. Having this third character in silhouette can emphasize the effect.

Punch Drunk Love. Directed by Paul Thomas Anderson. Columbia Tristar Home Entertainment, 2002. All Rights Reserved.

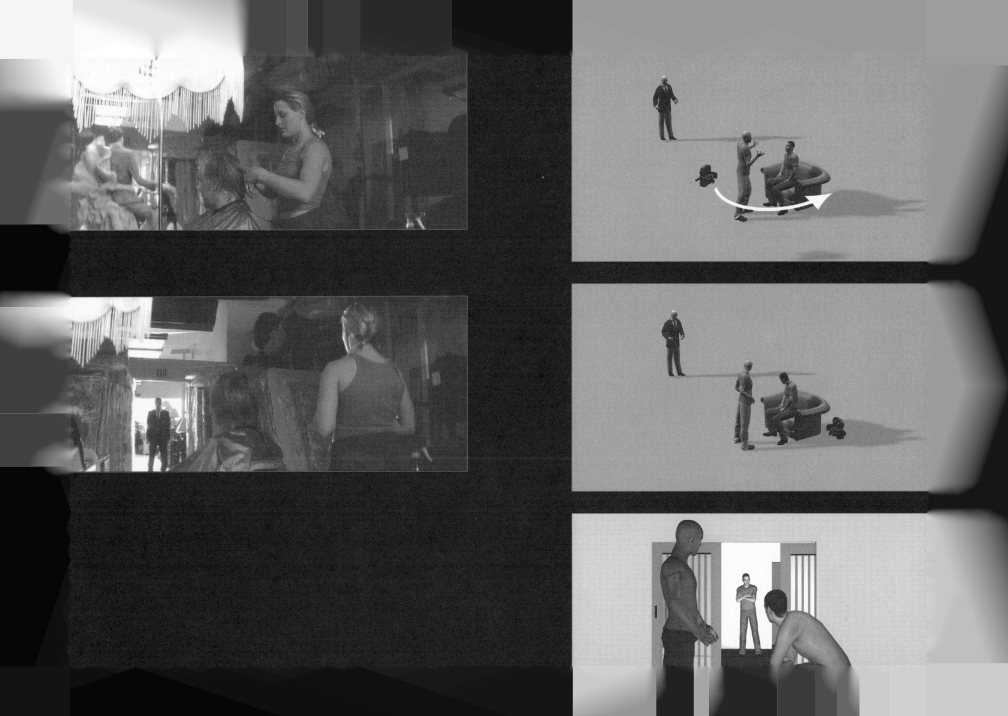

THE TURN IN

We love to see a character's face, so when a scene opens with a character's face hidden, we can't wait for the actor to turn around. The Turn In is a good way to introduce a character to a scene, when they are about to make an important announcement or change in their life, or start approaching their problems in a different way.

You can even start the scene with a few lines of dialogue, as the actor talks to somebody off-screen, before he ever turns to face the camera. It might help to set up your camera so that the other actor's shoulder is just visible in shot; otherwise the audience may think your hero is talking to himself.

In this example from *36 Quai des Orfèvres*, when Gérard Depardieu turns into the shot, the moment is made far more powerful because he walks straight up to the other character. If he had only turned around, it would look like he was staring out of a window and finally joined a conversation. The Turn In works because he turns in and storms into the scene, taking over and showing his strength and determination.

Don't get your actor to stare at a wall, or something else close-up, because it looks ridiculous. Give your actor a window or balcony to peer out from, so that there's a reasonable justification for him to be staring off into space.

Set up your camera behind the actor, with a long lens. Although you can move the camera to accommodate the actor's movement as he walks toward the second actor, the less movement this shot contains, the better it works. Set up your actors' marks so that the camera barely needs to move.

36 Quai des Orfèvres. Directed by Olivier Marchal. Madman Films, 2004. All Rights Reserved.

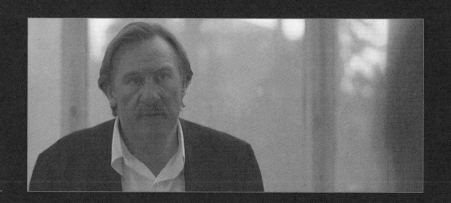

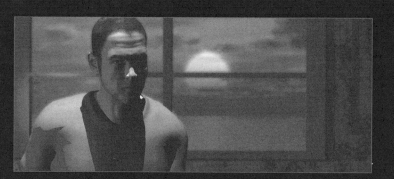

OBJECT REVELATION

There's something extremely powerful about placing a character dead center of the screen, when they first appear in the film. It's a way of saying that this person is important, so take note. One way to do this is to place the character in the center of the screen, behind an object, and then to move that object out of the way.

The simplest solution, as illustrated with these frames from *Crouching Tiger, Hidden Dragon*, is to have a door, or doors, open in front of the character. An ordinary door, which swings to one side, isn't as powerful as double doors, or sliding doors, which part to reveal the character. You can use other objects, such as cars or boxes that are pushed out of the way, but if doors are available, they work well. Whenever an audience sees a closed door about to be opened, it arouses their curiosity.

You can build this moment into a complex shot, with lots of camera moves, but when the doors are about to open, bring the camera to rest. The longer your lens, the more clearly we'll see the new character. Be wary of using too long a lens, though, or the door frames may not be in view. The door frames help frame the character, and this gives her much more significance than if she's standing in open space.

The character who opens the doors will have to stand to one side, which may feel a little artificial for the actor, but is essential for the new character to be visible.

To add real power to this shot, let everything come to rest for a moment — the doors, actors, cameras — and then have the newly introduced character walk into the room. This underlines her importance.

Crouching Tiger, Hidden Dragon. Directed by Ang Lee. Columbia Tristar Home Entertainment, 2000. All Rights Reserved.

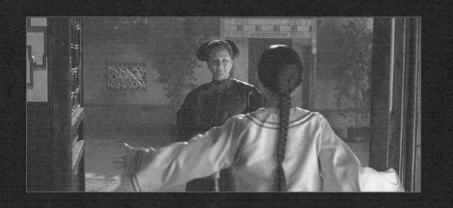

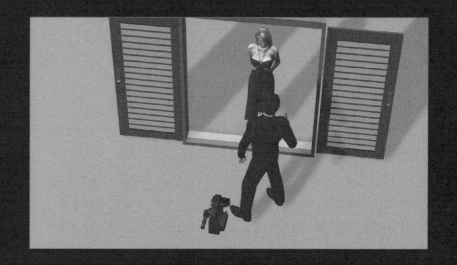

WINDOW PUSH

Sometimes you want a character to do more than simply leave the scene. You want to signal that she's leaving behind a part of herself, or a section of the film. At moments of such change, the Window Push is a good way to signal this sense of closure.

In these frames from *Amélie*, a simple combination of effects creates the correct emotion, without it looking like a technique at all. The camera moves toward the windows, as they are closed, and then the character walks out of the shot and turns out the light. It's the combination of these factors that makes this work.

When a camera dollies forward, we get the feeling we're going to see something new, so when the character walks out of the dolly shot and leaves a dark window, it creates the surprising feeling of closure. It breaks expectations. If the window was already closed, or the light already out, the effect would not be as powerful.

Set up your camera outside a window, and dolly smoothly toward your main character as she closes the windows, backs out of the shot, and turns out the light. Make sure there's plenty of light on the outside wall, otherwise the shot simply goes dark, rather than revealing the dark, empty room.

The technique can be varied in many ways to create other emotions. You could, for instance, follow a character toward a front door, which is slammed behind her, leaving us dollying in on a closed door. Or you could push in on a character sitting in a car, which drives out of the shot.

Amélie. Directed by Jean-Pierre Jeunet. Becker Entertainment, 2001. All Rights Reserved.

SCENE SWAP

Imagine that you want two conversations to take place in the same location, one after the other. How do you get one character to leave the location, and introduce the next character to the scene without awkward pauses or dead screen time?

The frames from *Always,* directed by Steven Spielberg, show how you can connect two mini-scenes. First we see Richard Dreyfuss ending his conversation with Holly Hunter. We see him looking at her, and then from his Point of View we watch her go up the stairs. At this point, you're expecting a cut to another shot or to another scene. Instead, John Goodman slides into frame, in medium close-up. After a couple of seconds we cut to a wide shot of Goodman sitting down with Dreyfuss, and the effect is complete.

By connecting the two mini-scenes visually, in one shot, they flow together. If Spielberg had simply cut from Dreyfuss to a medium wide of John Goodman walking in, it would have felt like two scenes were being forced together.

For this effect to work, the scene change should almost be seen through the eyes of the character who stays put. Set up your camera as though it's looking through this character's eyes, and follow the actor who moves away in the background.

The third character should be close to camera, stepping into the shot from the side. In most cases, the distance between the background and foreground characters will require a quick focus change at the moment the third character steps into frame. This focus shift enhances the effect.

Camera movement can be used to enhance the effect. In Spielberg's example, the camera follows Hunter up the stairs, and the camera keeps moving upwards to take in Goodman's full height.

Always. Directed by Steven Spielberg. Universal Studios Home Video, 1989. All Rights Reserved.

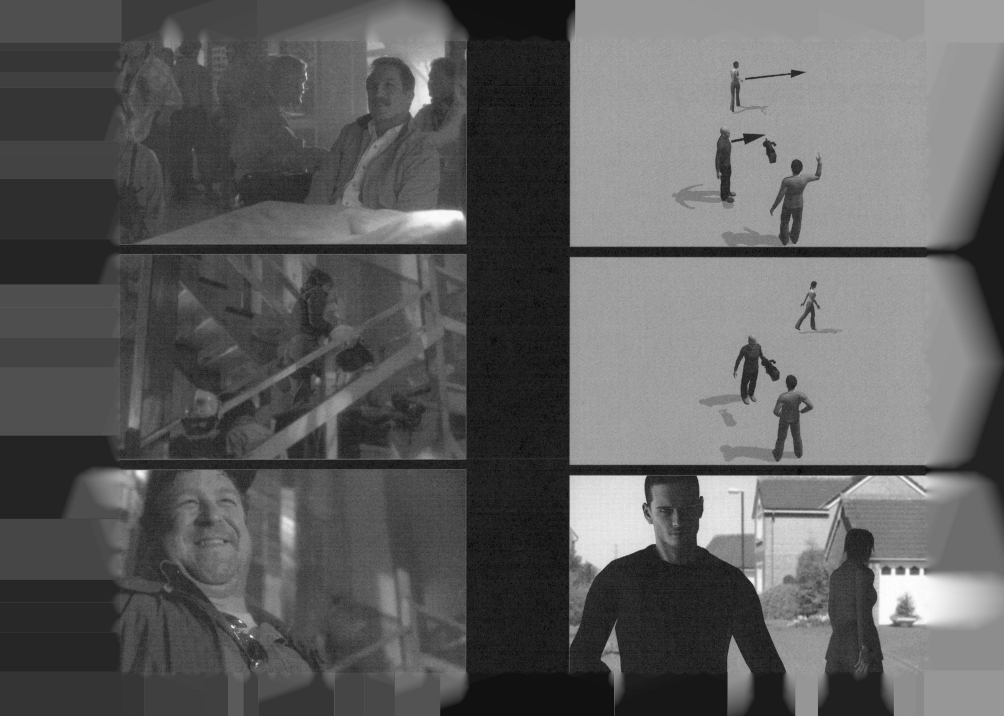

THE PENDULUM PAN

The Pendulum Pan is best used for a final exit, either from a section of the film, or from the whole film. It creates a feeling of closure, as though the character really is leaving, and is an ideal way to see a character leave the film for good.

From the frames shown here, it looks as though the actor walks past, and the camera pans after him. There is, however, a subtle move that makes all the difference to the overall effect. As the actor goes past the camera, the camera moves forward. It moves into the pathway that the actor was following, and continues to pan after him. For reasons best left to psychologists, this creates the feeling of seeing somebody really leave.

This is a particularly fascinating effect because it is so subtle. To see the power of tiny differences in camera moves, you can try shooting it both ways; once with a simple pan, and then with the Pendulum Pan. The difference is enormous.

Set up your camera perpendicular to the path that your actor is taking. It works best if the actor walks in a straight line, but it doesn't matter whether this is in a street, open space, or even down a hill. The camera pans as the actor approaches to keep him framed, but is otherwise motionless. Only as the actor steps in front of the camera does it begin to move toward him.

Continue to pan, but stop the forward movement as soon as you're on the actor's line of movement. All these moves should be gentle, although the pan will pick up some pace when the actor passes close to the camera.

An alternative approach is to have the actor further away, and a longer forward camera move, but in some locations and circumstances this can look forced and overly dramatic. Of course, that may be what you want, so this is a good move to experiment with.

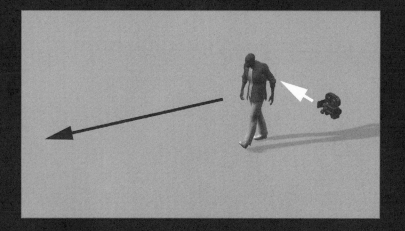

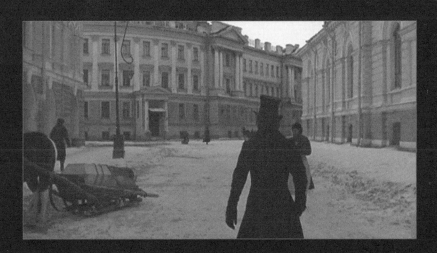

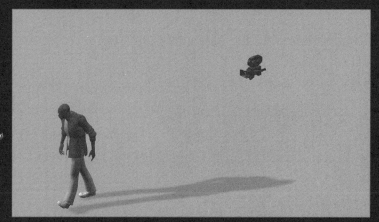

DIRECTION SHIFT

The Direction Shift is a special case, in that it can be used as an Entrance or an Exit. The shot begins with the camera some way back from the character, or characters, as they walk along. The camera tracks with them, keeping them in frame.

Toward the end of the shot they turn and walk toward the camera, as the tracking movement gradually slows down to a halt. To use this technique to introduce a character or characters to a scene, you would have them walk to this final position and begin a conversation, or perform some action. This sort of entry is best used when we already know the characters, and are introducing a new section of the film, or a new scene.

To use the technique as an exit, the characters should continue walking past the camera. This is not the sort of exit that creates real finality, but more of a sense that the characters are moving on elsewhere, and we'll catch up with them soon.

Set up the end of the shot first, with your characters in their final positions. This enables you to have a set camera height and angle throughout the shot, meaning there is no movement except the tracking. Now set up the beginning of the shot, and position your actors so they are in frame. You may need to make small angle adjustments while shooting, to keep them accurately framed, but the main sense of motion should come from the tracking move.

Timing of the tracking move can be quite difficult, so practice several times before shooting. The technique works well during dialogue scenes (so long as you have wireless mics), but if there's no dialogue, keep it short.

The Girl on the Bridge. Directed by Patrice Leconte. Madman Films, 1999. All Rights Reserved.

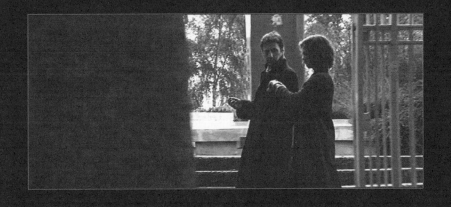

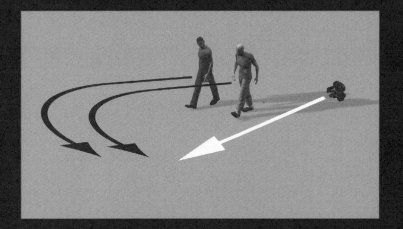

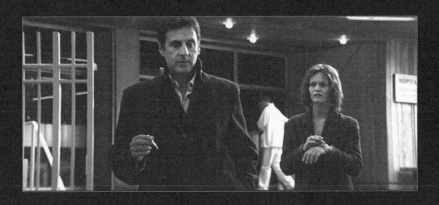

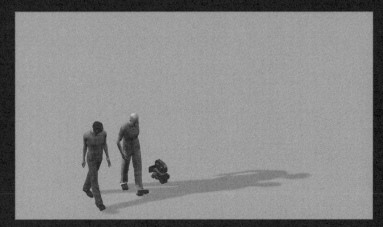

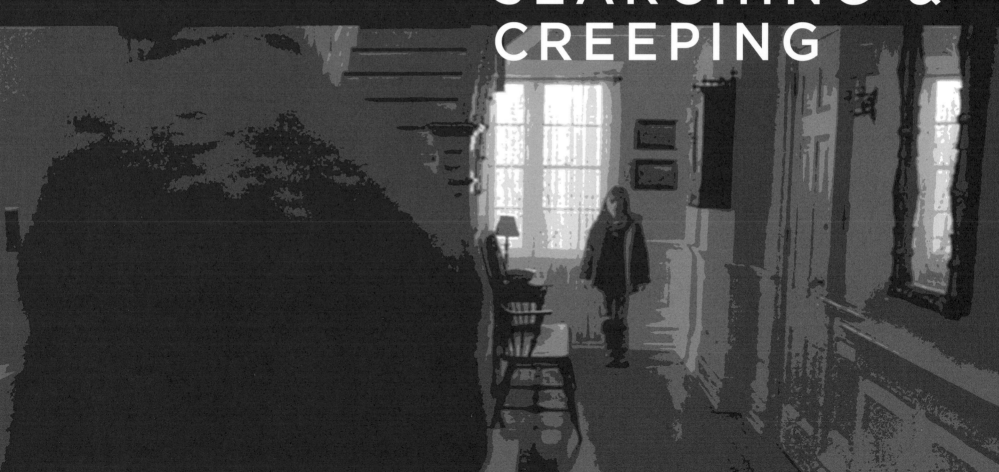

CHAPTER 4

SUSPENSE, SEARCHING & CREEPING

SUBTLE DOLLY

The Subtle Dolly, as its name suggests, is a camera move so slight that the audience won't notice the camera moving, but will feel uneasy.

This shot is used when characters are creeping around in a dangerous space, hoping not to be spotted, or shot at. As the actor creeps toward the camera, the camera moves back slightly. For the audience, this feels like we're backing up into dangerous territory. The last thing you want to do is turn your back on the danger, but that's exactly what this technique makes the audience feel. Sometimes the smallest moves have the largest effects. Without this move, the tension would have to come entirely from the actors' performance.

The example shown here has the camera set up close to a wall, and this also adds to the feeling that we're creeping around. The technique can, however, work in open spaces, because creeping around in an open space is also frightening. The trick is to have your actors moving forward, glancing around, while the camera backs off slightly.

Set up your camera pointing toward the actor, and have him move toward you. It's fine if he's looking off to the side, or above, but his movement should be directly toward camera, rather than weaving through the scene.

The camera should move back a short distance, and the actor should come to a rest close to the camera. The move doesn't need to end here, of course, because you can have the actor move off and continue with a longer shot.

If there's more than one character in the scene, try to keep the audience attention on one lead character. Get the other actors to follow a tight line, so they are barely seen behind the lead actor. If the actors spread out too much, it takes away the sense of danger and the need to hide.

Enemy at the Gates. Directed by Jean-Jacques Annaud. Roadshow Home Entertainment, 2001. All Rights Reserved.

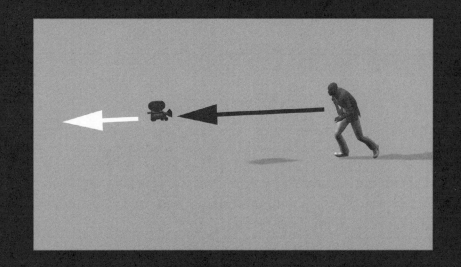

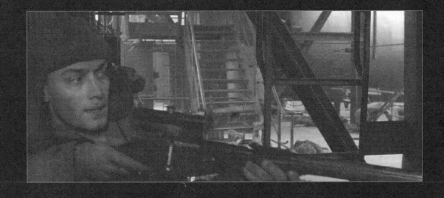

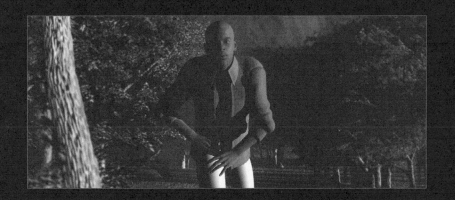

THE UNSEEN

It's been said so many times that it's almost a cliché, but things that aren't seen are far more frightening than those that are. What people often forget, however, is that it takes some skill to indicate that there is something out there, something that's frightening.

A technique shown here, from Philip Noyce's *Rabbit Proof Fence*, is an excellent example of how to create fear and tension by showing almost nothing. The characters are escaping from a tracker, and at this point in the film, he's a good distance away. The story could, as a result, become dull, but we want the tension to remain high until the tracker is much closer. Noyce shows this fear by having a close-up of the main character, and then showing her Point of View. But the Point of View isn't what we'd expect. She's not looking into the forest, but up at the treetops. Her Point of View darts from one tree to another.

For some inexplicable reason, this unexpected, jerky Point of View makes the actor's look into empty space feel like a moment of real dread.

It's unlikely that you'll want to recreate this exact scene, but the essential keys to adapting this for your own film are here. You need to get a good close-up of your actor looking afraid, in the context of an ongoing chase. This shot should be quite still. Don't go circling around, or dollying in. Keep the camera still.

The Point of View should be shot handheld, and at an unexpected angle. If this was taking place in a city, with an on-foot pursuer, it would work to have the character look up at the street signs. It unsettles the audience, they don't quite know what's going on, and fear is created.

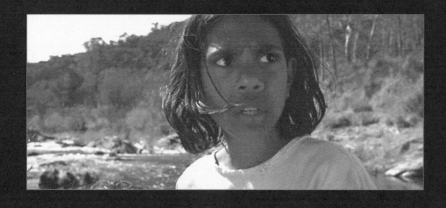

ANTICIPATING MOTION

In the middle of a chase scene, there's nothing more likely to raise tension than having everything come to a halt. So long as we know that the attack is about to resume, then coming to rest is far more frightening than actually being chased.

In these frames from *Blade Runner*, Harrison Ford's character makes it clear to the audience that he's anticipating something, because he points his gun into empty space, and every shred of acting ability is put into his body movement to convey this expectation. This is enhanced, however, by framing Ford as almost incidental, in the bottom right-hand corner. Our eye is drawn to the bright, empty space in the top left, which makes us know something is going to appear there.

When Rutger Hauer steps in, we're completely expecting his appearance, but it's still frightening.

Set up your camera behind your main character. This should be more than an over-the-shoulder shot, but should put your main character almost out of sight, so we look where he looks. There should be an empty space for us to look into, and also a plausible entry to this space. In other words, just looking down a dead-end corridor won't create any fear. But if there's a door on the left with light coming through it, we know somebody can come through that door.

Anticipating the appearance of the character is how you create the tension, and what you do with it after that is up to you. In this example, Hauer disappears in an instant, but you could just as easily have him run at the camera. This is a powerful technique because it can be used in many locations, and followed by any number of actions and shots.

Blade Runner. Directed by Ridley Scott. Warner Home Video, 1982. All Rights Reserved.

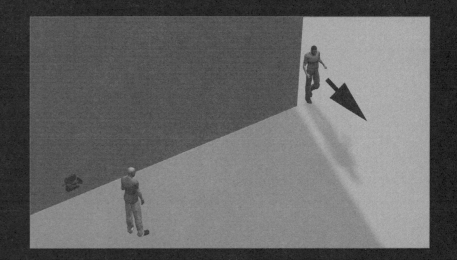

PUSH ON NOTHING

Without any scary music, or anything jumping out, you can create a sense of fear and tension in the audience. You do this by moving a Point of View shot through an empty space.

When you wander around a scary house or frightening street at night, you're scared not by what you can see, but by the expectation that something may appear. You see nothing at all unusual, but as you move forward, new things come into view, and you keep hoping nothing frightening will jump out. This is such a familiar human experience that it can be translated directly into film.

When your character's moving through an unpleasant place, you can create tension by letting the audience see things exactly as they would see them. You move your camera through the empty space.

In film, when you push in (or move toward) something, it can signify a thousand different things, but it nearly always means something has changed. To push through empty space means you echo the human experience of walking through a frightening place, while also using a cinematic signifier of change. This makes the audience worry that something is about to happen or appear. Whether you actually have something frightening appear or not is up to you, but to create this tension, you need nothing more than an empty corridor.

Shoot your character at eye level, moving the camera backward at the same rate they pace through the corridor. Then turn the camera around, and shoot the same scene as though from their point of view. Although pushing down empty corridors is frightening enough, a move through a door to one side heightens the sense that something unpleasant is about to happen.

The Shining. Directed by Stanley Kubrick. Warner Home Video, 1980. All Rights Reserved.

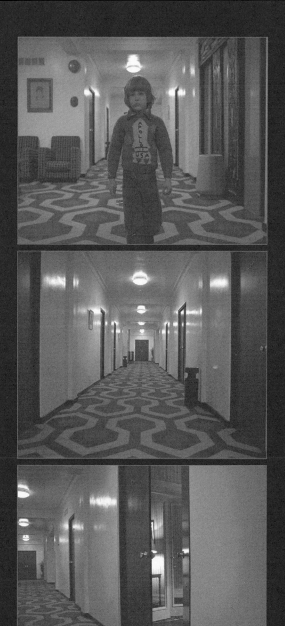

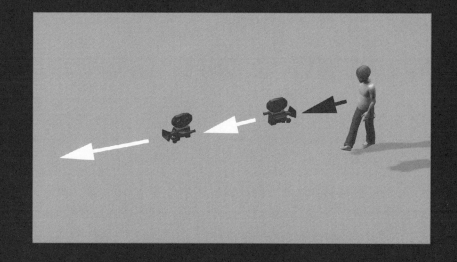

WIDENING THE SPACE

When your character is trying to escape from a heavily guarded area, there are several techniques that help raise tension of the scene. A classic is to keep the camera low, and look up at the character as he creeps around. This works because it feels unusual, and also obscures our view of the surroundings, making them mysterious.

Widening the Space is a technique that begins a shot low down, hiding the environment, but then has the character come down to the level of the camera. You can see in these frames from *Children of Men* that as Clive Owen creeps around, the camera pans with him, but also moves behind him. This means that by the time he's crouched down, we have an over-the-shoulder shot, looking into a wide open space.

In a few moments we've gone from watching him creep about, which makes us feel uneasy, to seeing what he sees — a huge, open space filled with guards, which will be impossible to cross. An empty space could work as well, but here the guards are a story point, letting us know that a challenge is ahead.

One of the difficulties with any slow escape is keeping the tension high. If handled poorly, the audience just gets bored. To keep tension high you have to keep adding new challenges, new obstacles, rather than just having one person tiptoe around. Widening the space is an excellent way to move from creeping out hopefully, to seeing the next big obstacle.

Set your camera up as low to the ground as possible, and pan with the character. At the same time, track across, so that you end up behind the character, looking over his shoulder. The pan and track should be executed to come to rest at the same time as the actor.

Children of Men. Directed by Alfonso Cuarón. Universal Studios Home Video, 2006. All Rights Reserved.

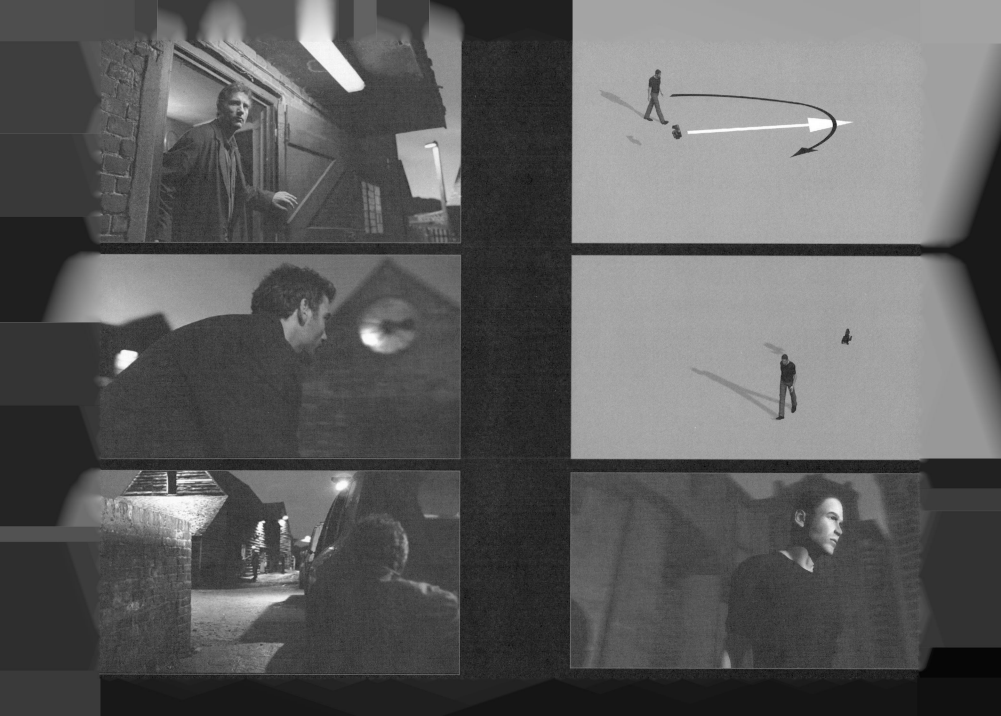

TWO THINGS AT ONCE

A great way to create a moment of shock is to draw the viewer into a false sense of security. Through careful shooting and editing, you can make the audience think that nothing is about to happen, and then have something happen. This tends to make them jump out of their seats.

In this example from *The Shining*, we see two characters in different places. We cut back and forth between them. Scatman Crothers gets closer to the hotel with each shot, and then gradually gets further into the hotel. Meanwhile Jack Nicholson wanders from corridor to corridor, in a different place in each shot. To the audience, it feels as though Crothers is closing in very slowly. This creates an expectation that the search will continue for some time. Then, when we think we're comfortably watching a shot of Crothers wandering down a corridor, Nicholson steps out from behind a pillar and axes him in the chest.

To build this false sense of security requires good editing, as well as good shooting, because the key is rhythm. You cut back and forth between two sequences, keeping each shot roughly the same length. If you were to speed up the cuts or shorten the shots, the audience would feel a build up to a confrontation. When you keep the shots at similar lengths, nobody expects the two sequences to meet so abruptly. It's obvious that Crothers is getting closer (because he's moved from outside in his car to the innards of the hotel), but you don't guess that he's quite so close to his doom.

Whatever way you choose to shoot this, it's a good idea to keep several parts of the sequence similar-looking. A good solution is to shoot the victim from behind, as though we're following him on his search. Do this in several shots, not just the last one. This way, the audience thinks it's just another shot, until the very last moment.

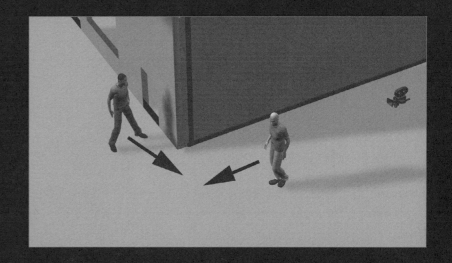

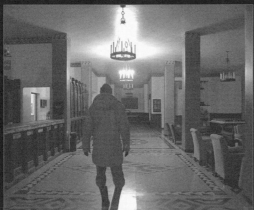

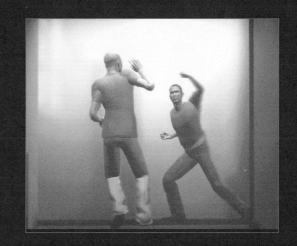

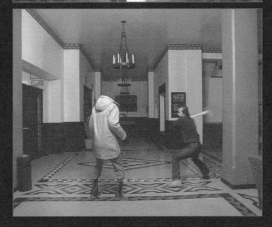

TRACES AND CLUES

Your character is desperately searching for something, and you need to show the urgency of this search. Whether they're looking for an object or a person, it is a challenge to convey this on film, especially if the one doing the searching has no dialogue.

One technique used by many directors is to keep showing the actor's face, trying to do all the work with the actor's expression. This can work, but often descends into near-farce as the actor is shown over and again looking desperately into a room, then cutting to a Point of View shot. It doesn't really engage the audience.

A solution is to stop trying to show us what the actor's going through, and let the audience experience it. You can do this by shooting from behind the character, and cutting to a Point of View shot. Set up one camera behind the actor, and move with him as he rushes around, looking into rooms and spaces.

Then reshoot the scene, with the cameraperson emulating the actor's movement and Point of View. When you come to edit, you cut rapidly between the two shots. It helps, of course, if you've made it clear what he's looking for, so we know we're looking into rooms and spaces that are part of the search, rather than the conclusion.

When the object or person is eventually found, that's the best time to cut to a shot of the actor's reaction.

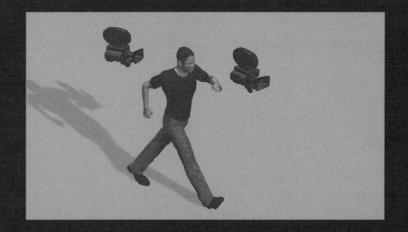

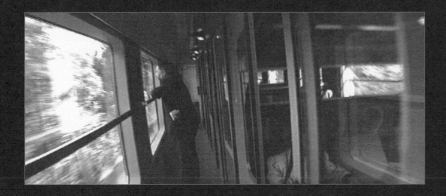

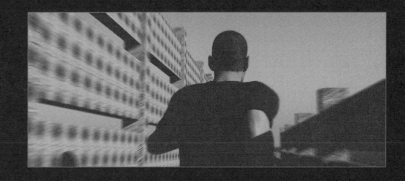

STEPS TO SUSPENSE

How do you show almost nothing happening, and keep the audience interested? One of the keys to create tension is to have your character looking or searching for something while the camera remains rooted to the ground, panning to follow.

For this to work, the scene has to come in the context of suspense or fear that's already been created, or it might look like your character is simply looking for the car keys. So wait for a point in the film where you want to show the character looking for something or somebody that can't be found.

The frame grabs show only a fraction of what Robert De Niro actually does in these few small moments of the film. He walks from left to right, then slightly up the stairs, back down and into a room on the right before looping back past the camera. This could potentially be deadly dull screen time. It would be a huge mistake, however, to try to add visual interest by moving the camera too much. If the camera followed him around this shot on a Steadicam, it would have almost no tension at all.

Set your camera up so that you can cover your actor's entire movement with nothing more than a pan, and a slight tilt where needed. It helps if there's some payoff at the end, as shown here, where the character of the daughter appears in the background.

You can make this effect even more extreme by setting the camera even further back and having even less movement, barely even panning. In theory, your camera could be motionless, depending on your location and the exact effect you're trying to create.

Hide and Seek. Directed by John Polson. Twentieth Century Fox Home Entertainment, 2005. All Rights Reserved.

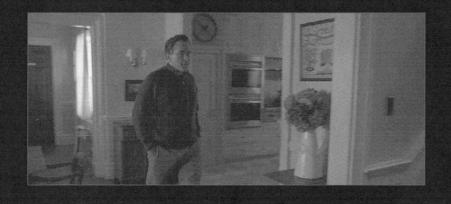

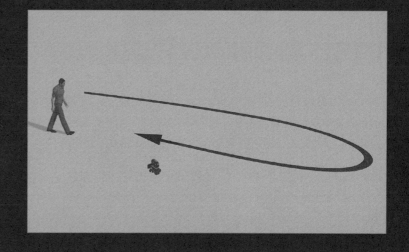

VISUAL DANGERS

According to Alfred Hitchcock's definition of suspense, the audience has to know something awful that the character doesn't know. These days the term "suspense" is used to mean anything from anticipation to tension, but the suspense that Hitchcock was so proud of is a great tool for filmmakers.

One way to make this type of suspense plausible is to show your hero and the danger in the same shot, but with enough distance between them that it's plausible for the character to be unaware of the danger. You need to use a long lens, to foreshorten the distance; otherwise whatever danger is in the background will appear too small.

Set the scene so that your actor is equidistant between the approaching danger and the camera, framed to the side. You will need to use a location where something on the opposite side of the frame to the character obscures the approaching danger. In this example, the car appears from behind the building. We go from watching a quiet moment of the girl walking, to seeing her pursuers catching up.

You can break the suspense within the same shot by having your character turn and see the danger, or by cutting to another viewpoint or angle at the moment of realization.

By using a long lens you also create a slightly eerie, nightmarish effect, where nothing seems to be moving closer, and yet the feeling of pursuit is extremely real.

Rabbit Proof Fence. Directed by Phillip Noyce. Magna Pacific, 2002. All Rights Reserved.

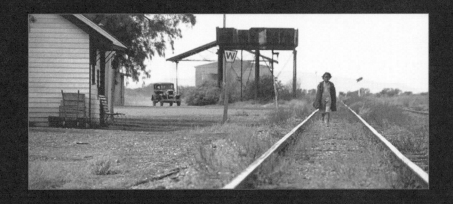

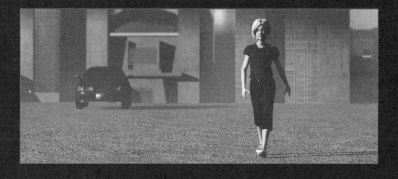

DRAMATIC SHIFT

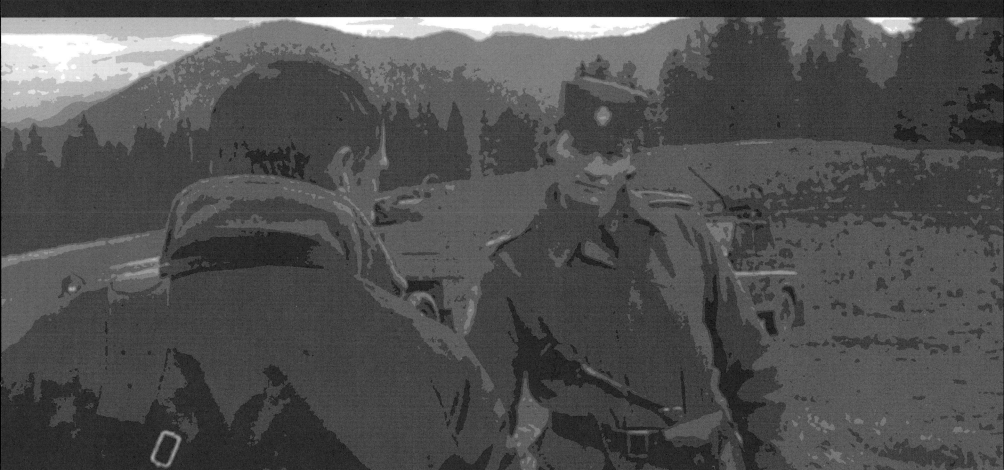

FOCUS IN

Once you get used to moving the camera, it's temping to move the camera all the time. A move that's particularly tempting is a relatively fast "push in." In this move, the camera simply moves toward the key character at a moment of change or realization.

Although this is one of the most commonly used moves and looks simple enough, it's easy to get it wrong. The audience isn't supposed to notice the camera moving, so much as feel the character's intensity.

This move can come in the middle of relatively stationary shots, or in the middle of a chase scene, so long as it is timed to match the character's reaction.

The main way that people go wrong with this shot is to allow the composition to change, by accident rather than design, as the camera moves in. To prevent this, the camera operator should keep one of the actor's eyes in the exact same part of the frame, throughout the move. It's best to use the eye that's closest to the center of the frame. By keeping one eye in exactly the same place, the audience doesn't feel the camera move, but feels drawn to the character's feelings.

Another mistake that's often made is to have the character's eyeline very close to the camera. The theory generally goes that the closer the actor is to looking into the lens, the more intimately we connect with the character. This is true, but it is wrong to assume that a push in requires a tight eyeline. In reality, too tight an eyeline can make the move feel forced or over-done. Also, it makes it very difficult for the actor to look into the distance when the camera is directly in the way.

Set up your camera at, or just below, the actor's head height, and use a fairly long lens to throw the background out of focus. A longer lens means you will have to move over a greater distance to make the push visible. It also means you'll need to pull focus with great precision.

Children of Men. Directed by Alfonso Cuarón. Universal Studios Home Video, 2006. All Rights Reserved.

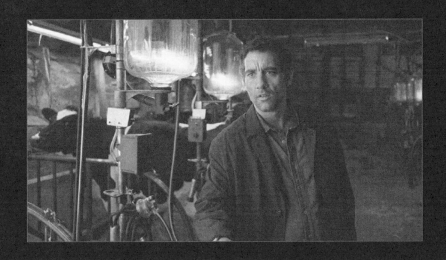

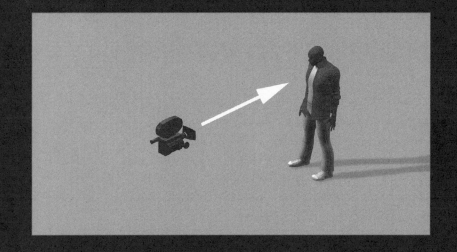

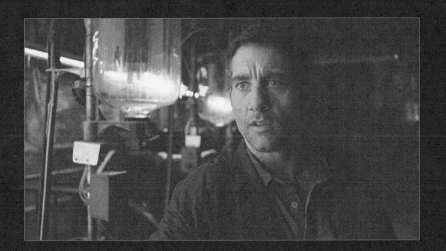

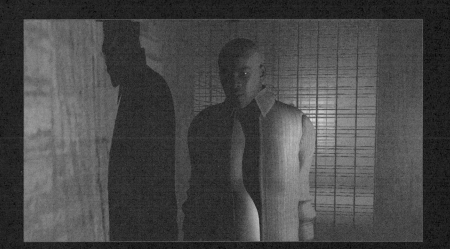

MOMENT OF DRAMA

When you need to show a moment of drama so intense that your character can't cope, the standard techniques may not be so useful. In standard cases, drama is emphasized by dollying toward the character. When your character is truly changed or distressed by a moment of drama, it can help to keep the camera still.

Instead of having the camera move, let the actor back away, as though stumbling away from the audience. In this scene, the character is close to the camera. We can't see what he sees, but he is clearly upset and he falls away into the background.

Set up your camera just below the actor's head height, and angle it up toward his face. Use a short lens, so that just a few steps backward will create a large change in the character's apparent size within the frame.

What you'll find, however, is that you can't leave the camera completely stationary, or the actor will drift too low in the frame. The only move you need, however, is a slight tilt down. Any other movement may distract from the effect. This tilt should be just enough to keep the actor's eyes on the same horizontal line throughout the shot. The camera operator needs to anticipate the actor's movement, and it's worth rehearsing this for the camera a few times before shooting.

Hour of the Wolf. Directed by Ingmar Bergman. MGM Home Entertainment, 1968. All Rights Reserved.

PAN AND SLIDE

At the beginning of a fight scene, or even just a dramatic showdown between two characters, you can emphasize the sensation of overwhelm that your character must be going through. A long, sliding move, which keeps the actor's face in view while making the background rush around the actor, creates a huge sensation of change.

To create this effect, your actor must step around in a little semi-circle, as the camera dollies past and into the distance. This keeps the actor's head facing the camera at all times. It almost feels as though the actor is stationary, and the world in the background is rushing past. The illusion is slight. If you actually placed the actor on a turntable, the effect would look ridiculous, but this move creates the feeling that the actor is suspended in a world that's whizzing around her. It's meant to feel dizzying, and on the big screen, it is.

The effect works best with quite a long lens, and with a fast move over quite a large distance. Set up your camera as shown here, close to the actor. The actor should always be looking just past the camera, as though the opponent is directly behind, or next to the camera itself.

As the shot begins, the actor should step around in a semi-circle, until she is facing almost completely the opposite direction. At the same time, the camera dollies past rapidly, panning all the time, to keep the actor framed. When executed carefully, the actor remains almost motionless, while the background rushes past. Only use a move as powerful as this if you're going to follow it up with something truly dramatic. This sort of move announces a big action scene, or dramatic change, so always follow up with one.

Crouching Tiger, Hidden Dragon. Directed by Ang Lee. Columbia Tristar Home Entertainment, 2000. All Rights Reserved.

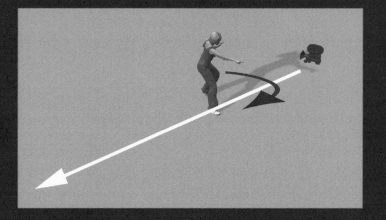

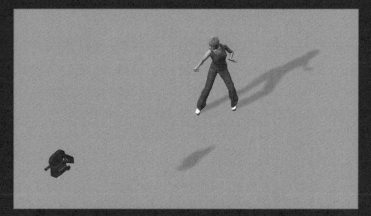

WORKING THE BACKGROUND

This technique is similar to the Pan and Slide, but works best at the end of a scene, rather than the beginning. It's a way of showing a conversation or fight come to an end, leaving one character alone in the bewildering world.

The shot begins with an over-the-shoulder view of the characters talking, and as the character who's facing camera begins to walk away, the camera operator rushes around, effectively taking that actor's place. At the same time, the camera pans rapidly, to keep the second actor in shot throughout the move. In just a few seconds you move from a simple over-the-shoulder shot to a dramatic mid-shot of the second character, with the distant background swirling past.

Set up your camera at the actor's head height, using a long lens to emphasize the camera movement and enhance the moving background. The move itself works best if carried out on a dolly, for the smoothness this brings, but the disadvantage of this is that the shot benefits from having a slight arc in the move. Without an arc, you may get too close to the second actor, partway through the shot. If you just set up the shot with a straight dolly track and the camera on a tripod, you might not get the results you're after. One solution is to use curved tracks, but not everybody has these. Another way to create this arc is by using a crane to swing the camera back briefly. You can also stand on the dolly platform, holding the camera rather than having it on a tripod or crane, and manually pull it back halfway through the move.

The shot can be done completely handheld, or with a simple Steadicam-type rig. Just walk in a semi-circle to take up the final position, and this should give you a sufficient arc for the shot to work well.

Behind Enemy Lines. Directed by John Moore. Twentieth Century Fox Home Entertainment, 2001. All Rights Reserved.

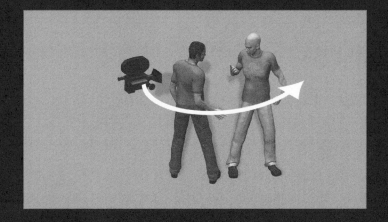

PIVOT ON CHARACTERS

A combination of actor movement and camera movement can signal that a major decision has been made. It's often said that films aren't about thoughts or decisions, but about action. This is because it's very difficult to see a decision on screen. One of the great challenges for directors is turning a decision into an action.

In the frames shown here from *The Lord of the Rings: The Fellowship of the Ring*, Elijah Wood signals as clearly as possible that a decision has been made, through his expression, but to make this really clear we also need to see him set off on his journey. The decision is made crystal clear through a dramatic camera move. As he moves forward, the camera rushes toward him, pans to follow him, and keeps moving back. This shift, from a relatively close shot of the actor to seeing him moving into the open world, happens in moments, and signals clearly that a decision has been made.

Set up your camera close to the actor, with a long lens. At the moment of decision, your camera should move toward the actor at the same speed he moves toward you. If you get too close, the actor's face will be lost in the move, so make sure there's sufficient separation for you to execute a pan that keeps his face in shot.

Once the camera has gone past the actor, keep moving backward as he moves forward, widening the shot, and seeing the character swallowed up by the world he's just chosen to enter.

The move can be carried out handheld or with a dolly, so long as the movement is timed exactly to match the character's motion. If the timing is off, the camera move draws attention to itself, and that should be avoided. Given that such moments require a lot of skill from actors, rehearse the move often enough that you can get this in a couple of takes. You don't want to wear your actor out while perfecting the mechanics of the move.

The Lord of the Rings: The Fellowship of the Ring. Directed by Peter Jackson. Roadshow Home Entertainment, 2001. All Rights Reserved.

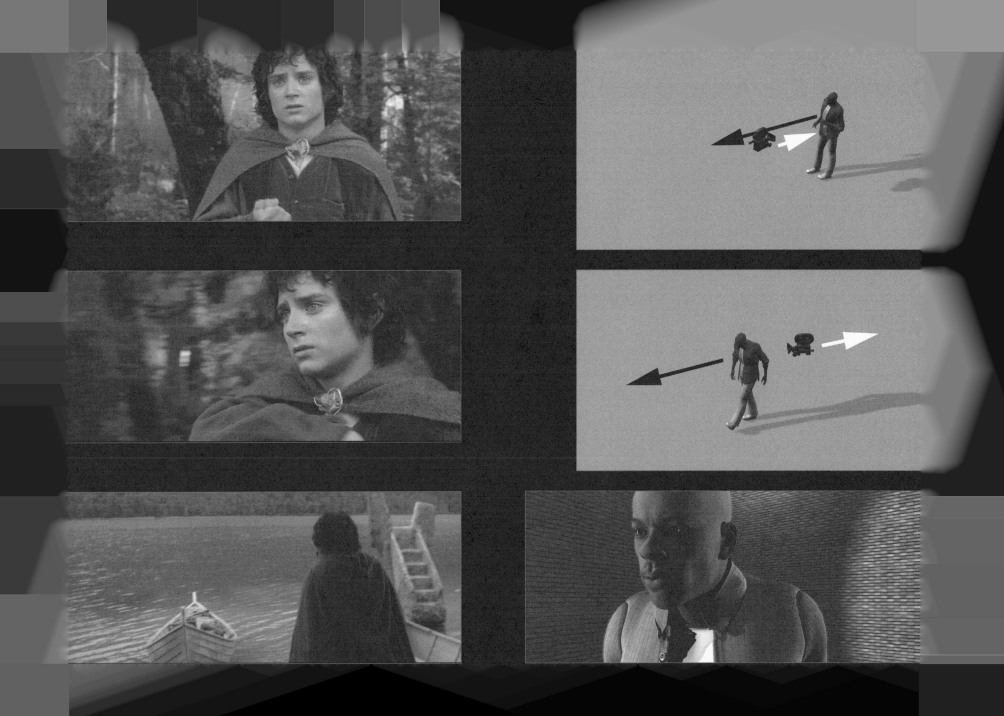

REVERSE ALL DIRECTIONS

This move can be used to show a character facing up to a huge challenge. It works by showing the character run from the danger, then turn to face it. In this example from *Jarhead*, the character isn't running in fear, but to take up a better position. You can adapt this technique, however, to show a character who initially runs in fear, then turns to face the enemy.

This move requires the actor to run past the camera, and then turn to look back in the direction he came from. At the same time, the camera moves toward the actor, and then swings around as he takes up his final position. The combined movement of actor and camera (as seen in Pivot on Character) creates a great sense of movement, but here, everything comes to a standstill when the actor has turned to face the action.

You can leave the camera alongside the actor, looking across his line of site, or completely reverse the camera direction, to look him straight in the eyes. For the best effect, the camera should be quite close to the actor at the end of the shot. You're not showing the danger (because that was already seen at the opening of the shot); you're showing the character's reaction to the danger, and his preparation for what comes next.

Your camera can be set up on a dolly, or handheld, and the camera's motion should be motivated by the actor's movement. This move works especially well at the end of a lengthy shot where there hasn't been much camera movement. This sudden lurch into action jolts the audience into realizing that danger is definitely at hand.

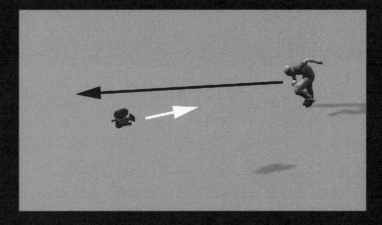

BACKWARD DOLLY

To show a character feeling trapped in a moment, while also keeping the shot dynamic and interesting, takes some skill. In this scene from *Thirteen*, the character tries to move away from her mother, but her mother tags along in pursuit. It's a dramatic shift, because she's trying to escape, but it's powerful because she can't escape as rapidly as she wants.

The camera remains quite still through the initial conversation, but when the actor takes off, walking away in despair, the camera backs away from her. The camera keeps the same distance from her throughout. It's almost as though the actor wants the camera to get out of the way. The audience feels as though they are in the way as well, and this helps to create tension. It's impossible to watch this scene without feeling the character's anguish.

At the same time, the second actor remains in pursuit, at exactly the same distance. Again, this helps to create the feeling of being trapped. We don't get a clear view of the second actor, but this doesn't matter, as the glimpses we get of her are enough to create the feeling of being pursued.

Set up your camera to cover the scene, with room to back off when the right moment comes. When the actor first moves from her mark, keep the camera in the same position until she is almost upon the camera. Then begin backing off, as though she is pushing the camera out of the way.

Although many backward dolly shots move from corridor to corridor, if you want to emphasize a character feeling trapped and trying to escape, stick to a single line of movement down the corridor.

There are many ways to end this shot, such as having the actor move off into a side room or push past the camera. When the actor pushes past, or moves aside, you indicate that the character has taken a significant action.

Thirteen. Directed by Catherine Hardwicke. Twentieth Century Fox Home Entertainment, 2003. All Rights Reserved.

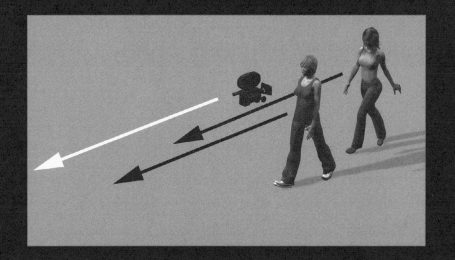

UNDERLINING STILLNESS

At the most dramatic moments your character may feel trapped in the moment. If you want your character to feel like a victim, hemmed in by circumstance and the actions of others, you can make great use of stillness. Keep your character still, while the world moves frantically around them.

For the best effect, you need your character to be fixing his gaze on something that's behind the camera. You can show the subject of his gaze in another shot, but when you come to execute this move, it's best if carried out without a cut.

The camera pushes in on the character while people move past him across the frame. We can see him clearly, because everything else is out of focus, but he struggles to see through the crowd. All the time the camera moves in on him, emphasizing the feeling of being trapped.

Set up your camera almost directly in front of the actor. It helps if there's a wall or other object directly behind him, filling the frame, to take away any sense of space. A long lens will help to throw foreground and background out of focus.

As the shot begins, dolly toward the actor as he looks past the camera, trying to see through the crowd. You only need a few extras to pass the camera. Too many and you'll hide the actor from view. If possible, avoid two extras passing each other within the frame, as this can distract from the main subject.

Your actor's eyeline should be very tight. That is, he should almost be looking into camera, so that we feel the intensity of his gaze.

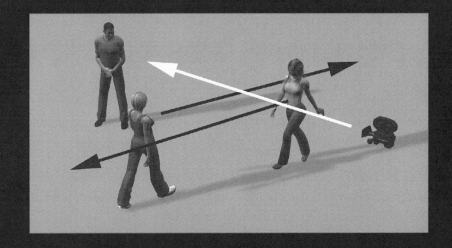

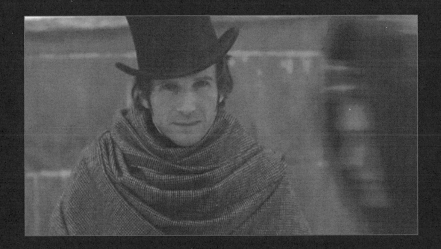

SIMULTANEOUS MOTION

Some of the most dramatic moments happen when a character tries to take action, but simply can't. We see their moment of defeat and suffer with them. Showing an internalized decision is difficult, so this technique uses moving props to emphasize the character's separation from her goal.

You begin by showing the character in close-up, facing the camera. She then turns away from the camera as an object passes across the frame. You then cut to a shot from the exact opposite position. This time she's framed much more loosely, so we can see the prop passing behind her. It's almost as though the passing object has spun her around and away from her goal.

The prop that passes your actor can be a trolley full of boxes (as shown here), a car, or anything else. It must be large enough to be seen in the frame on both sides of the cut, as well as being light and nimble enough to move rapidly in and out of frame on cue.

Set up your camera at head height, with a long lens, and frame for a close-up. The actor looks past the camera to her goal. At the moment she decides she can't achieve her goal, the object should move across the frame, and she turns away from the camera.

Reset the shot, with the camera 180 degrees around from where you began. Use a slightly shorter lens, and get a little closer to the actor, so we get to see the object moving away behind her. Timing is critical. Make sure your actor begins to turn when the object is in exactly the same position as it was in the previous shot, or editing will be a huge challenge.

Amélie. Directed by Jean-Pierre Jeunet. Becker Entertainment, 2001. All Rights Reserved.

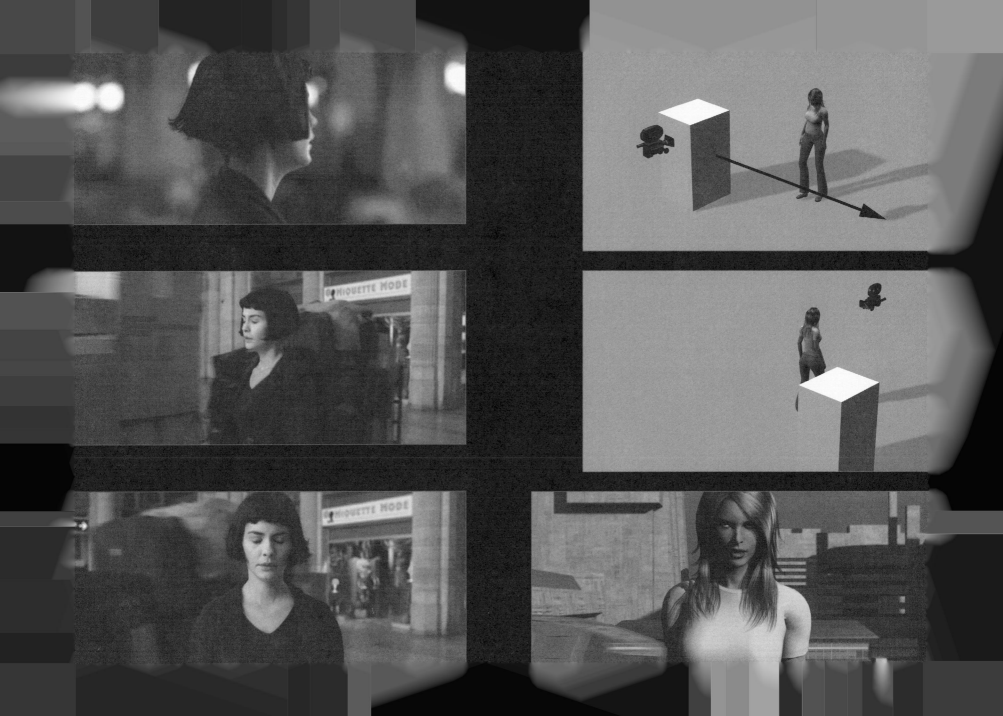

REVELATIONS & DISCOVERIES

MIRROR DOOR

The best directors always look for ways to reveal the scene without too many cuts. This keeps the audience engaged with the scene, and makes any visual revelation much more powerful. Showing everything in one shot also ensures that the audience doesn't become confused about who's doing what to whom.

In the example shown here, a mirror is used to show both directions, without a cut or camera move. We start by seeing a couple through a doorway. One of them reaches to close the mirror-door, and as it slams shut we see the third character, reflected in the mirror, watching them. This is much clearer than if we had cut from the couple to the lone figure, and has the effect of connecting him to his observation.

This technique also enables you to use completely different lighting styles for the two directions, without confusing the audience. If you simply cut from the couple to the observing character, you would need to match the lighting closely, so as to avoid confusion. By connecting the characters in one shot, completely different lighting styles actually enhance the effect you're trying to achieve.

Set up your camera behind the third actor, pointing through the doorway. Use a long lens, but make sure the edges of the doorframe are in view. Give the actors a reasonable motivation to close the door. For the audience, the appearance of the observer should be a shock revelation.

You may need to move your actor out of direct alignment with the door, to get the shot. This is fine, but make sure he looks directly through the door (rather than staring straight ahead), or the audience will detect the false eyeline, and the shot will feel wrong.

Minority Report. Directed by Steven Spielberg. Twentieth Century Fox Home Entertainment, 2002. All Rights Reserved.

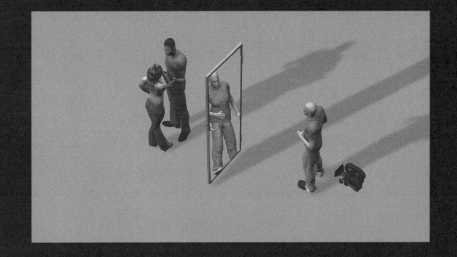

SEPARATING

You can reveal new information within a scene, by first concealing it behind another character. Imagine that you want to show the return of a particular character. As shown in this example, you can hide that character behind the other actors, and then have them move out of the way.

This technique works for other kinds of revelation, wherever the visual presence of a person or object tells the story. Despite the apparent simplicity, it takes some planning to execute this convincingly.

It helps if the person or object being revealed is partially in view at the beginning of the shot, or at least indicated by background activity. If you obscure the background completely, the revelation can be comical. Instead, the background person or object should be blurred and partially shielded.

Set up an over-the-shoulder shot, leaving enough space between the actors that the background can be glimpsed. The character standing alongside the camera should also experience the revelation at the same time that we do, so make sure it's plausible that the background is hidden from him.

At the moment of revelation have the character that's blocking the view move backward, or to the side. At the same time, the camera moves forward. This has the effect of moving the point-of-view character out of frame left, as well as bringing the subject of the revelation much closer to camera.

This technique is called Separating, because to get the best effect, there should be a sense that the frame is being opened up; one actor moves to the right (and shrinks in the frame as she moves backward), while the other moves out of frame to the left as the camera moves. This creates the sensation of curtains being pulled apart to reveal a secret.

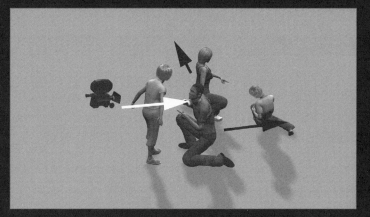

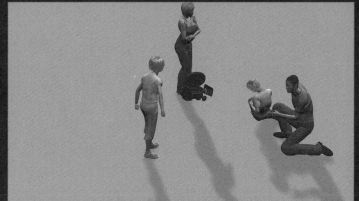

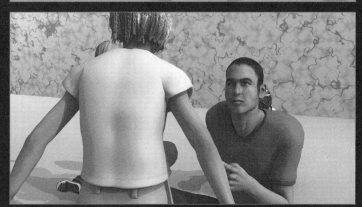

DETAIL IN THE CROWD

When you want the audience to spot an important character in a crowd, you need to use a careful combination of light and focus to draw their attention. Without this level of care, the shot will reveal nothing, and the character (no matter how famous the actor) will get lost in the crowd.

By using a long lens, you narrow the amount of image that's in focus; this means that when you focus on your character, just about everybody else in the shot drops out of focus. The eye is always drawn to bright, sharp areas. By making sure your character is more brightly lit than the rest of the scene, you emphasize the effect.

Set up your camera a long way back from the actor, and use a long enough lens to create the effect. If you're using available light, shoot in a shadowy space, and find a place where sunlight breaks through; position your actor in its glow. If you're lighting the whole set with lamps, give your actor more light than anybody else.

You can enhance the effect by having most of the crowd walk away from the camera, and have your character turn to face camera. If there are lots of faces in the shot, get the background actors to tilt their heads down slightly, or look off to the side a little. Your main character can guide her eyeline close to the camera.

Lost in Translation. Directed by Sofia Coppola. Universal Studios Home Video, 2003. All Rights Reserved.

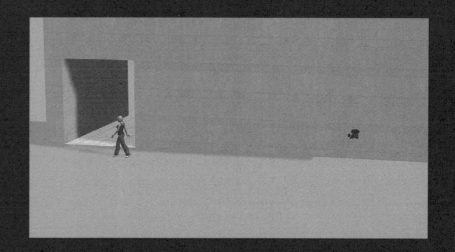

OUT OF THE SHADOWS

Sometimes you want to re-introduce a character to your film. That is, you want them to make a dramatic entrance to a scene, because you're approaching a significant moment in the film.

An actor's first appearance in a film is of great importance; actors and directors work hard to make sure that a character gets a great entrance. By applying this same level of dramatic entry later on in the film, you reveal to the audience that something major is going on.

In the example shown here, we see the character's outline, as well as some light in his hair. He then walks out of the shadows and we see his face. This isn't a true revelation, because the moment the audience sees his outline they know this is the main character. This is important, because if he's completely hidden in the shadows it would create too much curiosity about who is hiding there. By showing the audience that this is the main character, they are curious to see his face: what's he going through, how does this affect him, what's he going to do next?

This technique can be used partway through a scene, rather than just at the beginning, to show a shift in the drama. It works particularly well when something major is being revealed to the character in question.

Set up your camera low to the ground, looking up at your actor. There are many ways to light this, but make sure that when the shot begins, the audience knows who they're looking at. Have the actor move out of the shadows, and tilt the camera up. Keeping the camera in place creates the sensation of the character walking into the new scene; if you dolly backward, the actor doesn't feel like he's moving into the scene so much as passing through.

Artificial Intelligence: AI. Directed by Steven Spielberg. Warner Home Video, 2001. All Rights Reserved.

PULL-OUT REVEAL

When you want to show the audience what your character has just seen, there are many ways to achieve the effect. A simple cut will usually do the trick. Sometimes, though, you want to see the character's prolonged reaction, and let the revelation come over a few seconds. This slow dawning of realization can be more dramatic than instant shock.

In the example here, the camera moves along with the actor; then as she sees the ensuing riot, the camera almost comes to a halt. It moves backward just a foot or two during the move, panning to follow the actress as she moves past the camera. The shot ends with an over-the-shoulder framing, showing the crowd struggling to get on the bus.

By blending everything into one shot the director keeps the geography of the scene completely clear, and we also get to see that the confusion around the bus is far more interesting to the character than the riot itself. It's a perfect example of directing attention and revealing new information.

This type of swinging pan works best when there's something in the background moving in the opposite direction. Here, the director had a crowd of rioters pass close by the actor. This emphasizes that she's moving into unknown territory, and makes us pay attention to what is being revealed.

Set up your camera at head height, or slightly higher, and begin the shot at walking pace, moving backward with the actor. Then slow the camera, moving backward only a little, as you follow the actor around. The camera can now move behind the actor, looking past her at the scene beyond.

This type of move works well when performed with a dolly-crane combination, but a handheld move can add to the documentary feel of being in the moment as the drama takes place.

The Double Life of Veronique. Directed by Krzysztof Kieslowski. Artificial Eye, 1991. All Rights Reserved.

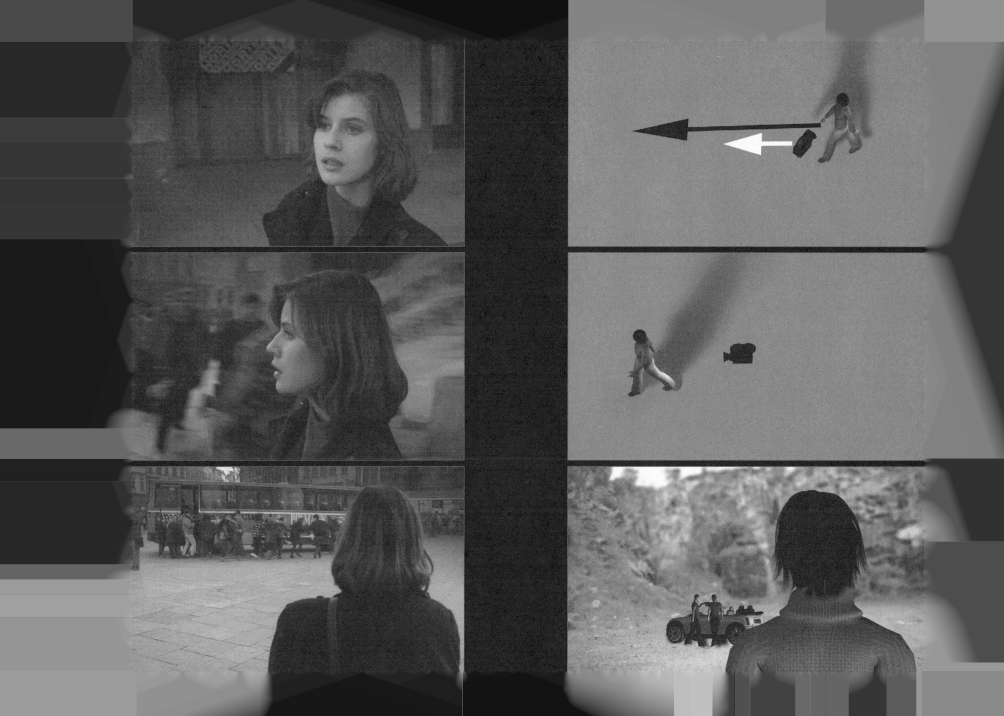

PARALLEL TRACK

At the moment of revelation, it's important to see the character's response. The Parallel Track creates the sensation that the character is caught up in a whirlwind of events, while keeping the actor's face in full view throughout the shot.

The example here shows how the actor moves to her right, while the camera rushes over to its right. At the same time, the camera pans to keep the actor in the same position in the frame. The effect is that the actor remains almost motionless, while the background rushes past.

In this example the director shot the same scene with two lenses, one much longer than the other. It's possible to jump cut between these two shots, so long as the camera move and framing is relatively consistent between the two. By keeping the actress frame-right throughout, it's easy to make the cut.

Set up your camera with a long lens, as shown in the diagram. When the shot begins, the actor needs a motivation to move, such as trying to get a better view of the action. As she moves, move the camera in the opposite direction, and pan to keep her in the same part of the frame. Repeat with a longer lens if you want to jump cut between the two shots.

The Double Life of Veronique. Directed by Krzysztof Kieslowski. Artificial Eye, 1991. All Rights Reserved.

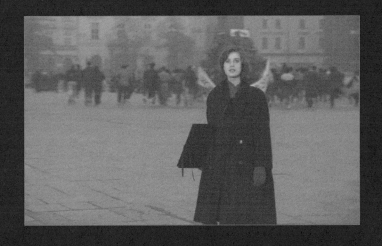

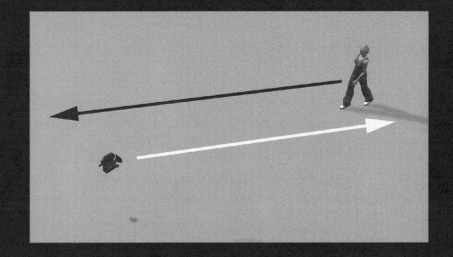

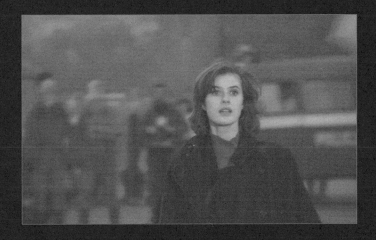

MOVING ON

When your characters are trying to escape, or get somewhere urgently, it's always a good idea to stop them in their tracks. Something unexpected should bring them to a halt. At that moment we need to see the look of shock and fear on their faces.

With this move, the camera rushes up to the actors, at exactly the same speed that they rush up to their marks. Even when you use a relatively long lens, this creates a sensation of great speed being brought to an abrupt halt. If you use too short a lens the effect can be too exaggerated, so a medium or long lens works well.

In the examples shown here, the camera moves slightly to the left of the actors. This works well, but you can also start the shot directly in front of the actors, shifting slightly to the side as the move progresses.

Set up your camera below head-height. This low angle means that at the end of the shot it almost feels as though the actors are going to run over the top of the camera, which adds to the drama. This low angle also has the effect of obscuring the background, which helps to focus attention on the actors' faces.

Once the move is complete, you need to cut to a Point of View or over-the-shoulder shot, to see the subject of their fear.

Terminator 3: Rise of the Machines. Directed by Jonathan Mostow. Columbia Tristar Home Entertainment, 2003. All Rights Reserved.

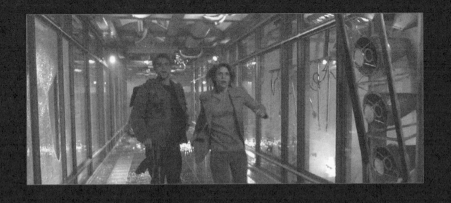

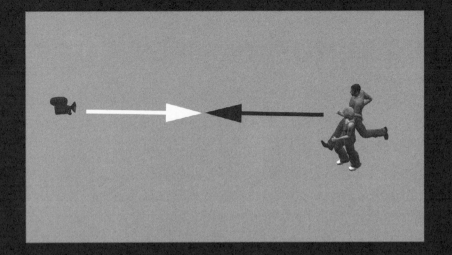

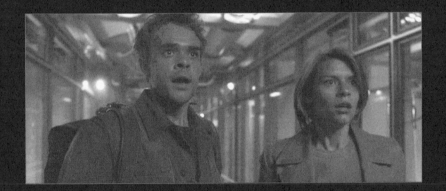

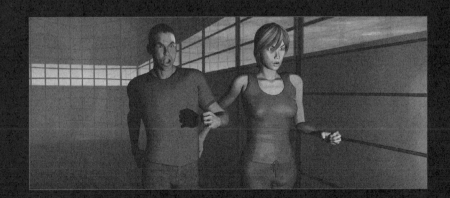

EYELINE CHANGE

When one character is joined by a second character, it's often a surprise, and one that the audience should share. In this example, we think we're watching the character deep in thought, but then the camera move reveals a second character approaching.

To get this right, the character's reaction (to hearing footsteps) should be quite gradual. If he just looks up, and then the camera moves in to show us what he's looking at, the move feels like an aftereffect. Ideally, the camera should begin to move at the moment he hears her approach, and be in its final position when he's completely turned his head.

This works well when one character is seated and the other is standing. Whatever position you choose for the first character, set up your camera at his head height.

Begin the move when the actor senses an approach. At first, this should look like a classic push-in on the character, keeping him framed in roughly the same position. Toward the second half of the move, the pan begins and we turn to see the second character.

You will need to pull focus between the first and second characters, and the timing of this is critical. Too early, and the main character goes out of focus while in shot. Too late, and the second character looks like they're in a dream sequence. Begin to shift focus at the moment the second character enters the frame, and complete the focus change as rapidly as possible.

36 Quai des Orfèvres. Directed by Olivier Marchal. Madman Films, 2004. All Rights Reserved.

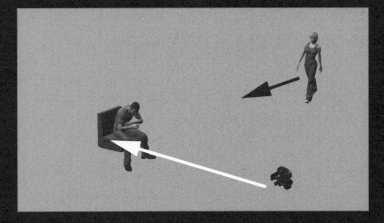

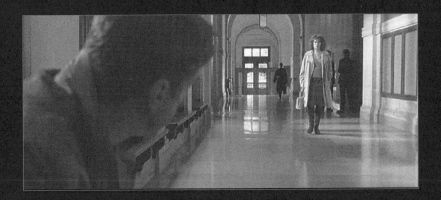

EYE SLIDE

A character's Point of View can be one of the strongest ways to reveal new information. This works when your character is expecting to see one thing, but actually sees another. In the example shown here, the character thinks he is creeping up on a sniper. When he gets there, it's actually a tailor's dummy dressed as a sniper.

After building expectation, it takes a lot of visual effort to break that expectation. Although the wide shot clearly shows the dummy, it takes a moment for the audience to work out what they're looking at, because they were expecting something else. The audience goes through exactly the same moment of surprise as the character. If you only use the wide shot, you'll find you have to linger on it for quite some time to make your point. Instead, you can use the Eye Slide move.

Cut to a longer lens, giving a closer look at the object or person in question. In reality, your character can't zoom in his vision, but the use of a longer lens simulates his attention being drawn into the details. He looks at one end of the dummy, and then slides his eyes rapidly to the other end. This fast motion, between slight pauses, creates a dynamic shot that gets the information across.

Set up your camera a good distance away from whatever object or person you're revealing. It helps to create tension if you're looking through something else, such as a hole in a wall. Shoot the scene with the camera motionless. Then change to a long lens. Start the shot at one end of the object, pause, then whip pan to the other end of the object.

Enemy at the Gates. Directed by Jean-Jacques Annaud. Roadshow Home Entertainment, 2001. All Rights Reserved.

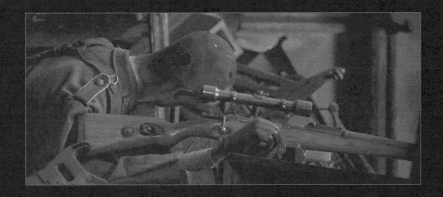

SHOCK HORROR

BUILDING TENSION

One way to create suspense is to stare into empty space, expecting something to appear. To make this even more frightening, you can hide the view from the audience for a while.

In the example shown here, the character is staring into an empty corridor, listening for sounds of approach. That is frightening enough, but is made more tense by beginning the shot with the empty corridor out of view. As the camera slides along behind the character, and we finally get to look down the corridor, the tension is unbearable.

The move itself is nothing more than a simple track and pan, but knowing when to use this is key. It doesn't work if you're actually revealing something in the corridor. If you reveal a big alien at the end of the corridor, as the camera slides across, that simply leaves the audience feeling cheated, because they were excluded from information known to the character. By tracking across to show empty space, the audience shares the character's unease.

Your character should, therefore, be staring through a doorway, down an alley, or into another space. Set up your camera low to the ground, to increase the sense of vulnerability. Frame your character on the left, and maintain this framing as you track across. When the move is complete, your character will either turn and run, or walk into the empty space.

Alien Resurrection. Directed by Jean-Pierre Jeunet. Twentieth Century Fox Home Entertainment, 1997. All Rights Reserved.

MISDIRECTION FOR SHOCK

Audiences love to jump at a moment of surprise, but they hate it when you try to surprise them and fail. With modern audiences being so aware of movie techniques, it's more difficult than ever to make them jump. Many directors fail, because they show the protagonist walking down a corridor with their back to a big empty space, and the audience just knows something is going to jump out.

A variation on this technique is to show the character shocked by something mundane, such as a can of paint falling over, and just as they sigh with relief, the serial killer jumps out. Again, this is such a cliché that the audience nearly always sees it coming, and there is no genuine surprise.

To actually surprise the audience, you should build tension, apparently relieve tension, and then, when the audience relaxes, shock them. One way is to have the character apparently distracted by something off-screen. In this example from *Minority Report*, Tom Cruise leans over the pool, and we're tense, wondering if something is going to happen. But then he looks up and calls across to somebody off-screen. Just at the moment we're wondering who he's talking to, the girl leaps out of the water, and the audience jumps out of their seats.

Set up your camera so that your character appears to be alone in the shot. You can go in quite tight, but if you stay out wide the audience is less suspicious of an impending surprise.

Have the character look past the camera, to something off-screen. This forces the audience to wonder what he's looking at, who he's talking to, and what he's about to say. This is a genuine distraction, and means the audience is guaranteed to be surprised. A moment after the second character (or monster) jumps out, cut to a tight close-up, perhaps from an extreme angle, so that we engage with the character's shock.

Rather than just having a random noise happen off-screen, which catches the character's attention, there should be a legitimate reason for the character to look off-screen. In *Minority Report*, Cruise's character asks a question to somebody off-screen, which makes perfect sense for his character at that moment. This is better than forcing a random event to happen, just to create the distraction. The more logical and character-driven the distraction, the better the surprise will be.

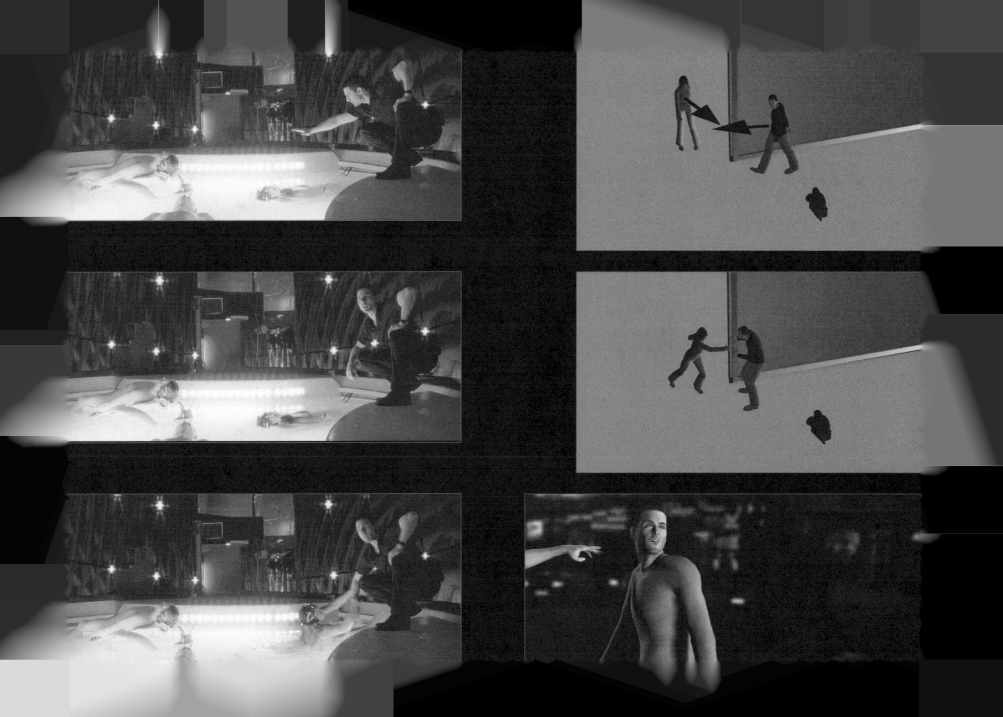

FEARING A CHARACTER

Characters who've been driven over the edge are usually far more frightening than any monster. A good script and good acting are essential, but the performance can be enhanced greatly by a simple camera move. Essentially, you keep the villain's eyes in the exact same part of the frame throughout the scene.

The example shown here was shot by Kubrick in the nearly square 4:3 aspect ratio, but was cropped to widescreen for the cinema. In both versions, the effect is the same, because no matter how Jack Nicholson moves, the camera compensates to keep his eyes in the same part of the screen. This is true within each shot, and even between shots in the same scene.

To make this even more frightening, the victim appears in the same part of the frame as well. This is only possible when you frame your characters centrally. The slight "jump cut" feeling adds to the effect. It also applies whether or not you're using an over-the-shoulder shot.

How you set up your camera will depend entirely on the subject matter of the scene, but to get this move right, direct your camera operator to keep the actor's eyes in the same part of the frame. Direct your actors to limit head and body movement, so the camera doesn't have to jerk around to follow them. To create the sense of fear, have one character back off, while the other follows. As Kubrick illustrates, you don't need to be limited to straight lines or one level for this shot to work.

The Shining. Directed by Stanley Kubrick. Warner Home Video, 1980. All Rights Reserved.

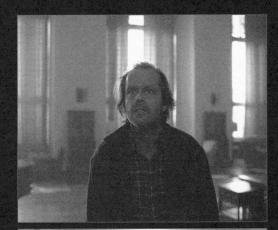

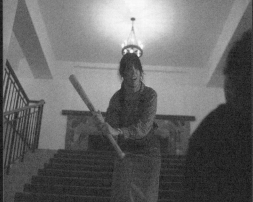

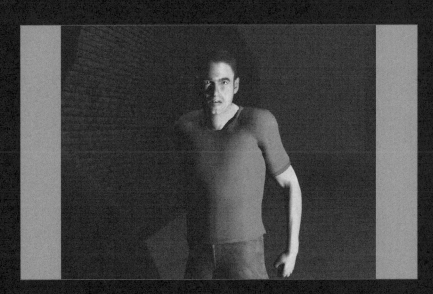

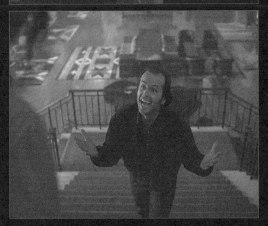

FEARING A PLACE

In horror movies and thrillers, we expect characters to be afraid of other people, monsters, explosions, and so on. Surprisingly, though, the fear of a place is one of the most powerful ways to convey a character's unease. In truth, nobody is ever scared of a place; you're scared of what might be there, or what might appear. In that moment, though, you look into the empty space and feel the fear. If you can capture this on film, you create a strong moment that will live on in the audiences' mind.

The way you position your actor is a crucial part of this. The effect you want to achieve is of feeling somewhat trapped, but at the same time being in a relatively open space. This apparent contradiction is solved by putting your actor up against a wall, as shown in this example. This lets the audience see that the character is backed up against a wall (literally and metaphorically), and that there is a long corridor behind her. This is much more effective than showing a shot from directly in front of her.

Her gaze, past the camera, makes us want to see what she's seeing. When we then cut to the shot of an empty space, we share her fear of this place, wondering what's going to happen next.

Place your actor against a wall or other object, and position the camera as close to the wall as possible. Frame the actor so that she is to one side of the screen, revealing the dark space behind her. Then, reverse the camera and show the empty space she's looking at. Do not shoot from behind the actor, as this is meant to be a Point of View, and the actor should not be seen in the shot at all.

Underworld. Directed by Len Wiseman. Columbia Tristar Home Entertainment, 2003. All Rights Reserved.

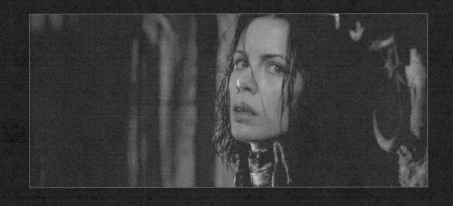

WIDE SPACES

When your characters are walking in a wide-open space, there are many opportunities to create fear. The example shown here demonstrates how a change of direction signifies a move into danger. In this particular shot it's emphasized because the characters are leaving a visible path, but it works equally well when no path is visible.

The shot begins with the characters in a wide space, which is scary, because the light drops off so dramatically. What's unseen in the dark captures the imagination of the audience. The characters then move off their path, and the camera moves with them. To the audience, this feels as though they're moving out of the light and into the darkness. If this takes place in daylight, it feels like moving from the known and ordinary into the unusual and frightening. It's so powerful that it should be used only when your character is truly taking a step into the unknown.

Set up your camera directly in front of the actors, and have them walk toward the camera. When they get quite close, have them move off their path (whether there's an actual path or not) and track with them. The track shouldn't be quite fast enough to keep up, so that they move out of the frame as they walk.

The timing of your tracking move is critical. It should begin at the moment the actors move off the path. Although this move is quite abrupt and noticeable, that's what you want. If you started the shot with camera moving, the audience would not sense any change when the actors move off the path. Keep the camera still, and then move with the actors. It's important to let them move out of the frame, to signify that they're going into the unknown.

An American Werewolf in London. Directed by John Landis. Universal Studios Home Video, 1981. All Rights Reserved.

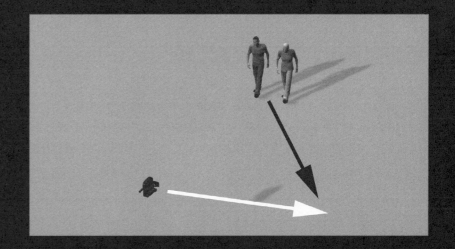

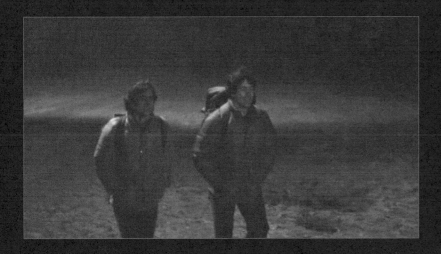

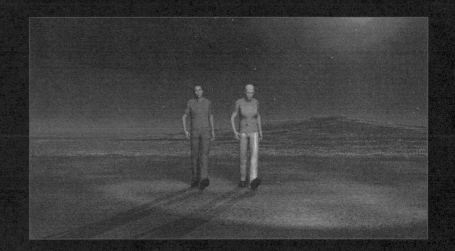

VISUAL SHOCK

One of the best ways to give your audience a fright is to fill a previously empty space with something unexpected. In this example, we see Claire Danes struggling to start her car, and as she bends to pick up her keys we see the empty space through the window. When she sits back up, her attacker is standing outside the window.

To get this to work, you don't want the audience to know that a surprise is coming within the same shot. They know a surprise is going to happen soon, because the character is being pursued, but you need to misdirect them. Here, the struggle with the car keys appears to be the subject of the shot, even though it's actually building up to the moment of shock.

The effect works best when there are no cuts, so your move should begin by showing an empty space behind the actor, then move to show something else, then move back to show the space refilled. This does not work well if you neglect to show the empty space first. If this shot began on the car keys, then moved up to reveal the attacker, there wouldn't be much surprise at all.

Set up your camera so that the foreground actor appears to be framed in a relatively conventional way. That is, don't leave a huge empty space around or behind her, as this gives the game away. So long as the audience sees an empty space, even if glimpsed, that is enough.

Move or tilt your camera to follow the action. Make sure the motivation is realistic, such as a dropped object. When the actor moves back into the original position, move the camera into its original position. Block carefully to ensure that the second actor is clearly framed, perhaps by getting the foreground actor to sit further back than before.

Terminator 3: Rise of the Machines. Directed by Jonathan Mostow. Columbia Tristar Home Entertainment, 2003. All Rights Reserved.

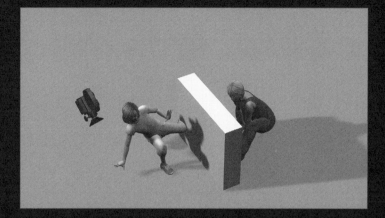

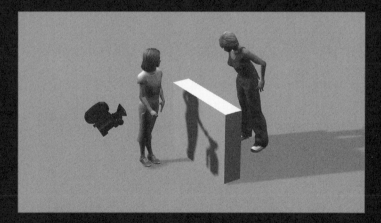

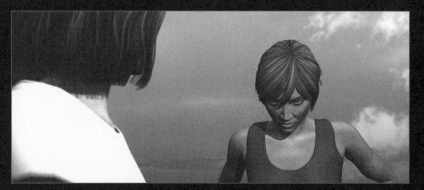

A CHANGE OF MIND

When a pursuit is underway, one of the ways to make it seem more horrific and frightening is to have your characters struggle to choose an escape route. Rather than seeing them run, watch them struggle as they move in one direction and then another. You can emphasize this by moving the camera around them as they shift.

The example shown here illustrates this well. Upon hearing ominous howling, the characters turn away from the camera. The camera moves faster than they do, and gets in front of them as they come to a halt, uncertain of where to go.

Once again, they turn and move away from the camera. Although they are in a different place, this repetition of their turn and move away from the camera is essential for the best effect. Without this repetition you still create a sense of unease, but the repetition emphasizes that they aren't really getting anywhere.

You can start your shot with the characters facing the camera, but they should then turn and move to the side. As they do, arc your camera around them, moving faster than they do. It's almost as though the camera gets in their way and causes them to stop. Then they turn around and walk away from the camera once more.

You can cut between several different versions of this shot, to really stress how trapped they feel. When the attacker is heard but unseen, you get the strongest sense of despair.

An American Werewolf in London. Directed by John Landis. Universal Studios Home Video, 1981. All Rights Reserved.

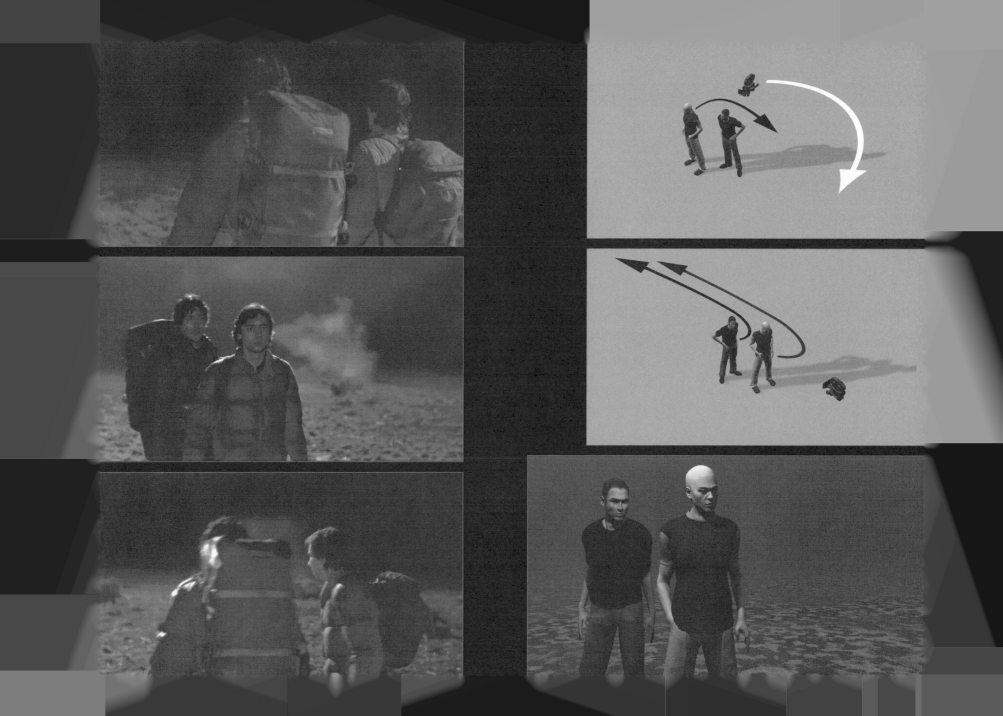

SHIELDING ATTACKER

Misdirection is the key to creating surprise. If the audience is convinced to pay attention to something else, they will be surprised when the attacker returns. For this to work you need it to seem impossible for the attacker to catch up, and you need to give the audience something else to focus on.

Here, Harrison Ford is struggling on a window ledge. That gives the audience something to think about. They don't forget that the attacker is out there, but they're wondering whether he'll fall, rather than whether he'll be attacked. Secondly, it seems impossible that the attacker could leap out here; it's a window ledge, after all. When the attacker bursts through the boarded-up window, it's a complete surprise, and the audience jumps out of their seats.

Set up your camera with a long lens, with the unseen attacker closer to the camera than the other actor. This makes the attacker's appearance more dramatic. The long lens also foreshortens the distance, making it seem unlikely that anything or anyone could fit into that space, thus increasing the moment of surprise.

Time the attacker's appearance to come just a moment after the other actor makes a move. As Ford reaches for the window ledge, that's the moment the foot bursts through the window. By combining many layers of misdirection, you create a strong effect.

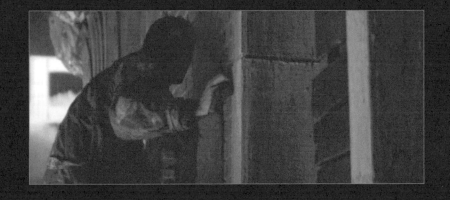

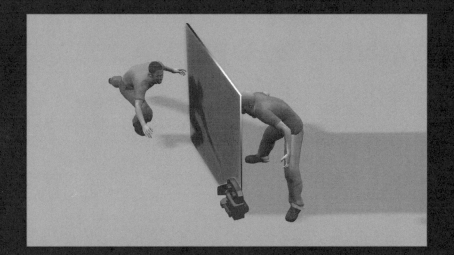

WINDOW OF FEAR

There are few things as frightening as a face appearing at a window. The problem is that we are so used to seeing frightening faces appear at windows, that the moment we see an empty, dark window, we expect to see a face there. If you want the moment to really shock, you have to give the audience something else to think about.

The trick is to have your character do two things at once. In the example shown here, the character is tying to do something to the door, at the same time as she's trying to do something with the faucet. She can't quite reach both at once. By having her torn between the two things, the audience is directed to really pay attention to her struggle. We watch her hands, and we try to work out if it's possible for her to do both things at once. This means we completely forget about the blank, dark window, even though we know it's there.

Better still, her movement between the faucet and the door means that as the camera follows her movement, the window goes momentarily out of frame. When the window reappears, the face is in shot.

Your camera can be set up on a tripod, with no more movement than a simple pan to follow your actor's movement. What's important is that you set up a plausible conflict for her to deal with. Make sure she has two pressing needs that she needs to move between, in order to make the audience forget about the window.

Friday the 13th Part II. Directed by Steve Miner. Paramount Home Entertainment, 1981. All Rights Reserved.

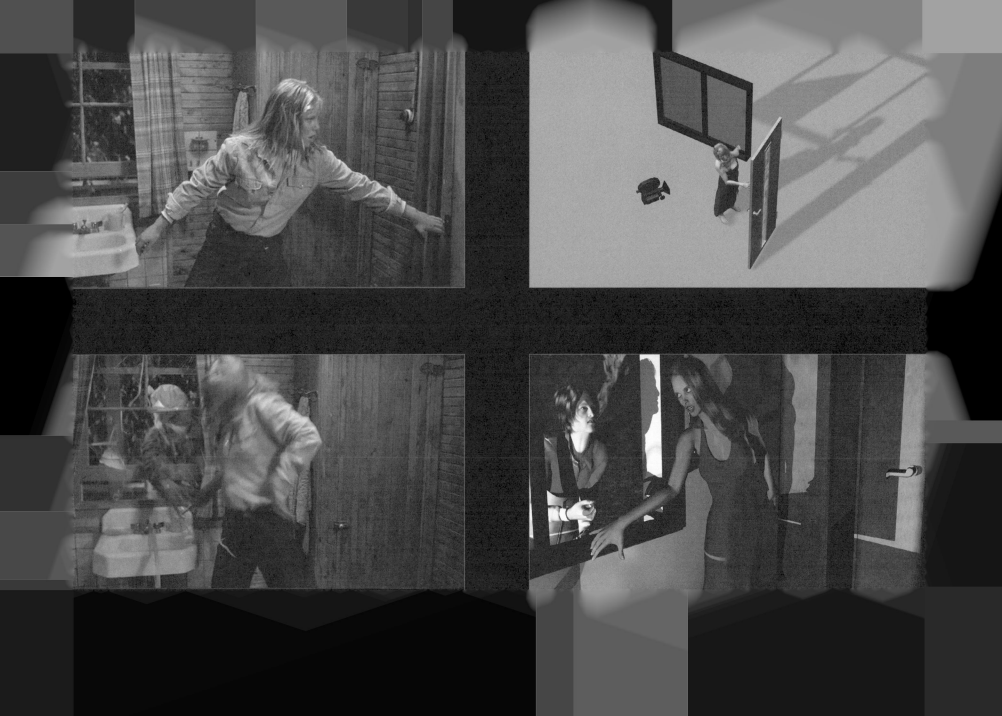

DIRECTING ATTENTION

OBJECT GUIDE

When you're shooting a continuous scene — without cuts — how do you move from one place to the other without it seeming forced? In truth, most directors don't bother about this, and either cut from one place to another, or just pan from once character to another. That's fine, but not as flowing and beautiful as a choreographed shot that camouflages the movement behind an action.

This example shows how a relatively insignificant piece of paper is used to give the camera a motivation to move. The first character hands the paper to the second character, and we follow her as she takes it to the third. The piece of paper is not insignificant, but neither is it the focus of the scene. It merely gives us a reason to move from the right of the set to the left. When executed well this is far more satisfying than simply cutting, or swinging across without motivation.

In this example, the two sides of the scene are in communication with each other. They are talking to each other across the café, so the move joins the two parts of the scene. You can use this technique equally well to end one isolated conversation, and move to another within the same location.

Set up your camera so that you can see the whole scene just by panning. Although you can track in the middle of this shot, the simple version involves nothing more than a pan. There are no set rules about how to frame or compose the beginning and end shots, except to say that each should be composed as though it was a finished shot in itself.

The transition, where the actor moves past the camera, should be relatively brief, as it isn't interesting enough to hold the attention for more than a moment. It is a transition, rather than a journey.

State and Main. Directed by David Mamet. Twentieth Century Fox Home Entertainment, 2000. All Rights Reserved.

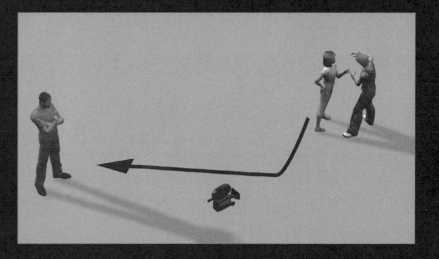

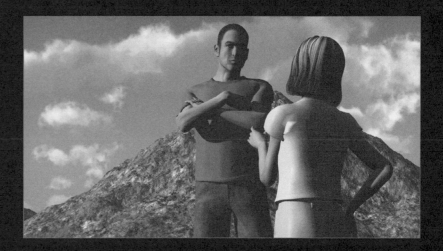

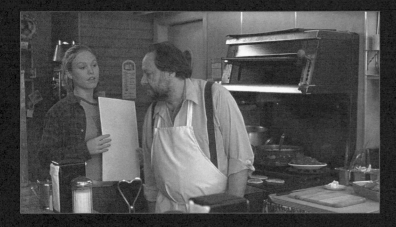

HANDING OFF MOTION

In a busy scene, where more than one thing is happening at once, you can switch between the main areas of action with a subtle camera move. This enables you to show the whole scene without a cut. Although there has been a trend in recent years, to cut-cut-cut in order to imply that things are moving fast, you can achieve more by avoiding a cut altogether. By letting a busy scene play out, the viewer sees all the various story threads taking place in one frame, and it enhances the sense of urgency and drama.

For this to work, you want the characters to be on the move, shifting around the room. Give them good motivation — they should be fetching a file, for example. Don't just have them wander around (unless, of course, that is the point of their character). In the example shown here, James Woods is wandering soulfully through the chaos, and that's the point. He's meant to be a calm center of focus in the middle of the drama.

The move itself is nothing more than a backward dolly, timed to coincide with a character's movement. In this example from *Contact*, Jodie Foster moves toward the camera, and it backs off, as if to make room for her. As it does so, a space is left open for James Woods, and then the focus is on him.

To the audience there is no sense of a camera move, only the sense that we're first with one character, and then with another, as a fast-moving scene takes place.

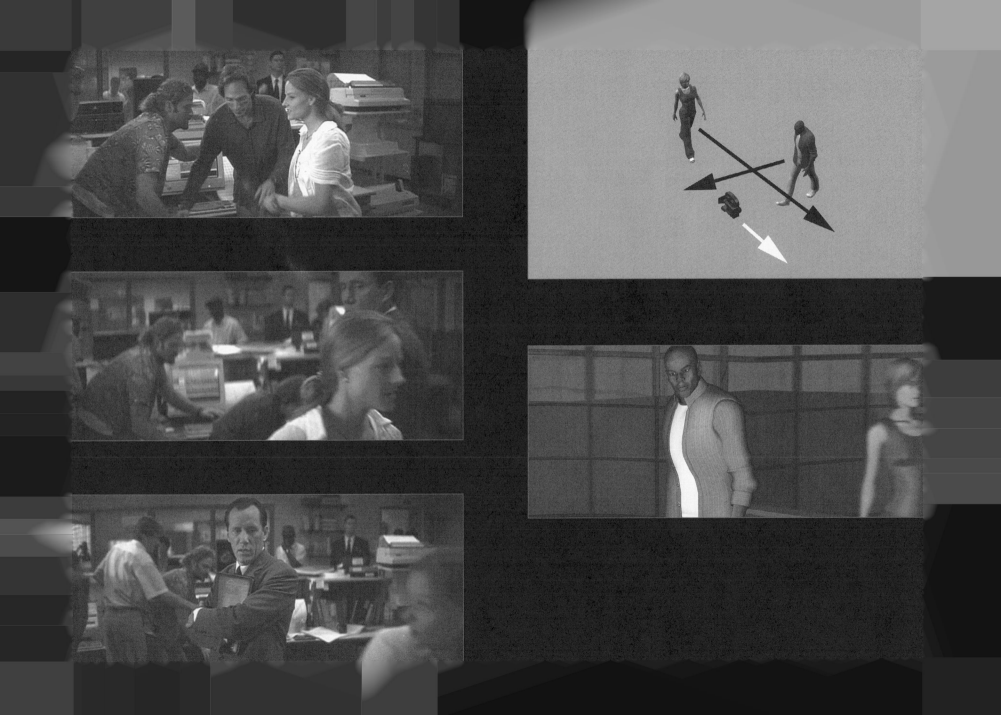

CHANGE OF DIRECTION

A sense of space is sometimes essential to the story, and you want to show the audience that your characters are located within the space. Rather than just panning around to show them the space, you can use the characters' motion to motivate a camera move that lets the audience see the whole landscape. Of course, they don't see everything, because the crew are all standing behind the camera, but they get to look in both directions, and it feels as though they've seen the whole landscape.

You could just point the camera at the actor and pan with them as they walk past, but this lacks any sense of dynamic motion or flow. It's better to move the camera with the actors, dollying backward as you go, and then have one character move faster than the other. As she runs or jogs past the camera you pan with her, slowing the move to a rest. You do need a good motivation for her to run — don't simply have her speed up because it's convenient for your camera move.

It helps if the actor who moves faster is initially behind the other character. This emphasizes her sudden movement. Rather than having her run straight forward, have her run across the other actor's path. This brings her much closer to the camera, which adds to the sense of speed. This is important for the camera move to be carried off without drawing attention to itself. You don't want the audience to sense a big camera move; you just want them to watch a character run off into the wider world.

You can think of many variations, with one or more characters moving off, but the advantage of having just one character run is that she can look back toward the off-screen character, which lets us see her face. A face is usually more interesting than the back of somebody's head.

Eternal Sunshine of the Spotless Mind. Directed by Michel Gondry. Roadshow Home Entertainment, 2004. All Rights Reserved.

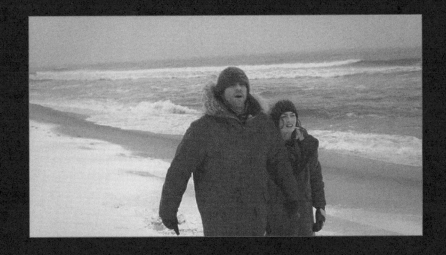

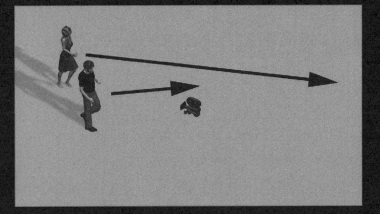

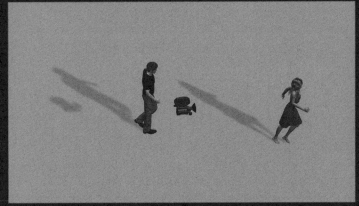

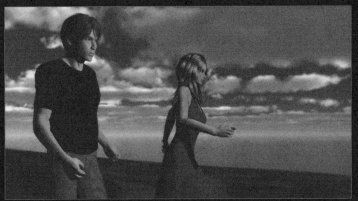

REFLECTIONS

Some of the great directors, such as Steven Spielberg, use reflections so frequently that it is almost a trademark. There is a good reason for this. Reflections enable you to show two things at once. In the example shown here we can see Irene Jacob's reaction to the choir, while seeing the choir at the same time. This is far more elegant than cutting from a shot of her to a Point of View shot.

You can use this to direct the audience's attention to the background, by having the actors stare off-screen. This guides our eyes to the side of the frame where the reflection lies.

The larger the mirror, the more flexibility you will have in setting up this shot. Where possible, have the actor actually look at the subject they are meant to be looking at. It's common to cheat eyelines in many shots, but when using reflections a cheated eyeline can register with some viewers as being somehow wrong.

Reflections can be used in slow, gentle scenes, as shown here, or it can be used at a moment of revelation. As somebody bursts through the door, you can show the appearance and reaction in the same moment. Lens choice is challenging. If you use too wide a lens, then the reflected subject may appear too distant. But with a long lens, the reflection will always be blurred unless you pull focus to the background (taking the foreground out of focus).

For sudden revelations, you may need to cut shortly after the moment of shock, to show a close-up of the person who's just burst in, to help solve this problem. You certainly don't want to keep focusing backward and forward between foreground and background, as that doesn't guide attention so much as confuse the viewer.

Don't be limited to mirrors. You can use glossy tables, walls, and other objects. Watch Spielberg's *AI* to see countless uses of reflections to show two things happening at once.

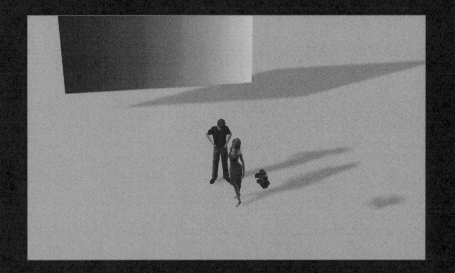

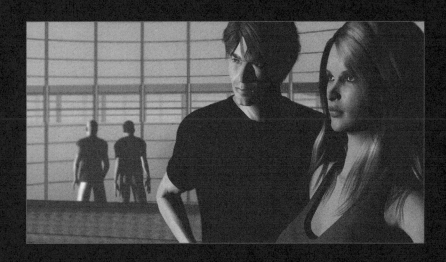

REST POINT

You often need to show a character reacting to a physical object that is handed to them, such as a letter. There's obvious impact to be had when this revelation brings the character to a halt, and literally stops them in their tracks.

This camera move doesn't follow any of the objects or characters directly, but is always heading for a close-up with the main character in the scene. This creates a great sense of gravity, as though this moment of revelation was inevitable. The camera moves straight there, letting the actors move away, in and out of shot, but ends in that close-up.

In the example shown here, the shot begins with the camera following the actors as they run for a school bus. As the bus (and the mother holding the letter) comes into view, the camera continues to move at the same pace, even though the actors speed up. The camera continues its move, passing the mother, as the daughter turns and comes back. The camera stops when it gets close to the daughter. It's a brief series of movements and motions.

Plan this scene so that, wherever the shot begins, the actor ends on a mark just in front of the camera's resting point. You need to time this so that the actor comes to rest at the same moment as the camera, or perhaps a beat or two earlier.

It's vital that your actor initially ignores the letter – or other object – so that she moves off into the background. If she simply stops when the object is offered, the effect is destroyed. The sensation you're creating is of a magnetic moment, and everything is drawn into it, including the camera.

White Oleander. Directed by Peter Kosminsky. Magna Pacific, 2002. All Rights Reserved.

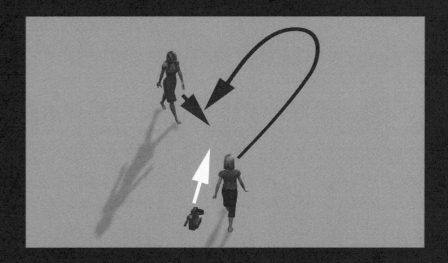

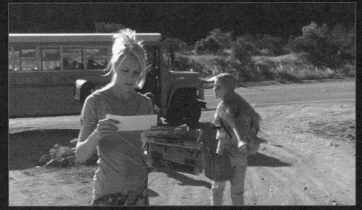

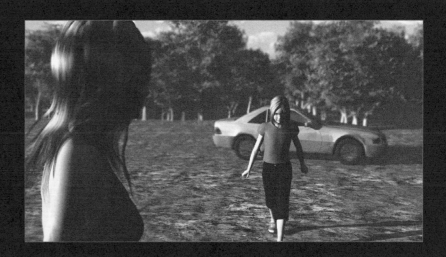

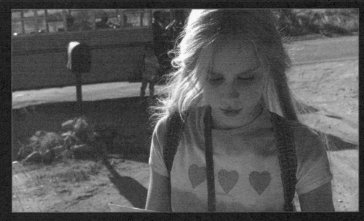

COLOR GUIDES

Color can be used to direct the audience's attention just as effectively as any camera move. In this scene, the audience needs to know that when a figure appears distant and blurred behind Jim Carrey, it's the same character we saw earlier. By giving the character a strikingly colored jacket, the effect is achieved.

You can't give your actor a bright orange jacket if it doesn't suit their character, but you can always introduce an element of contrast. The effect is enhanced here by the fact that the rest of the shot is graded down to blue. There are almost no colors other than the blue wash of the entire shot, with a dot of orange. When Kate Winslet appears behind Jim Carrey, the audience has no doubt who they're looking at. We've just seen a reasonably close shot of her in the orange jacket, so the connection between orange and the character has been made. If she was wearing an indistinct color, then her blurred appearance in the background would not be so obvious.

This technique is particularly useful when the background character's appearance is significant to the foreground character. There should be no slow dawning for the audience; we need to know in a beat who that is in the background.

You can use a long lens, quite close to the foreground actor, letting the background blur out. The subconscious audience expectation is that a shot like this will only focus on the foreground, but the splash of color draws attention to the background, and then the foreground actor reacts.

Eternal Sunshine of the Spotless Mind. Directed by Michel Gondry. Roadshow Home Entertainment, 2004. All Rights Reserved.

REVERSE ANGLES

When people argue, or discuss anything dramatic or important, they rarely stay still. You need to direct the audience's attention to the character who's dominating the scene (or talking most) at any time.

When you shoot a scene like this, the actors will want to be on the move, and it will look better if they are. People who argue circle around and pace. The challenge for you is to capture this movement without the audience losing track of where they are in the shot. One way is to shoot a relatively wide master shot, with almost no movement.

By keeping the camera essentially in the same place, and moving the actors, you can capture all the motion and emotion of the scene without any complex moves.

To make this work, you need to block the actors' movements so that the character who is doing most of the talking faces the camera. Then, when the second character does most of the talking, the actor's motion should already have taken place, so that she is now the one facing the camera.

The main problem with a shot like this is that there is always one actor facing away from the camera. Make sure you give that actor enough body movement and body acting to give them a presence throughout the scene. You aren't shooting close-ups, so both actors have to give it their all in every shot.

If, while shooting this, you feel you didn't get a single perfect take, you may need to shoot some coverage to enable a cut. This doesn't have to be coverage of the face; you could just as easily get coverage of hand and foot movements, which would enable the cut, while maintaining focus on the energy of the argument.

The Game. Directed by David Fincher. Universal Studios Home Video, 1997. All Rights Reserved.

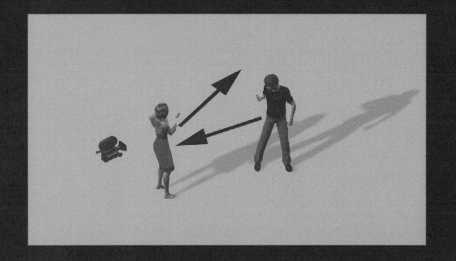

CAR SCENES

FRONT SEAT SHOOTING

There are few contemporary films that don't have a scene set in a car. The challenge is to get good shots, without having to spend all day setting up complex rigs to carry the car and vehicle. The alternative, low-budget approach is used in many films with great success. You put the camera in the car with the actor, and shoot from one seat to the next.

In the simplest terms you place the camera in the front seat, and point it into the back of the car. By using a long lens, you let the actor's face dominate the scene, so that it's about the actor and not the car.

There are many ways to stabilize the camera, such as keeping it handheld and letting your body absorb the shocks from the car. Whatever approach you use, make sure you drive the car at an abnormally slow speed. So long as the background is moving a little, you'll create the sensation of the car moving along. You don't need to speed along when all you're filming is a conversation.

As a general rule, the actor usually looks across the empty space in the frame, but that's not usually possible with this sort of set-up. As you can see from this example, Winona Ryder looks to screen right (even though the empty frame space is screen left). This feels a little unbalanced, which is perhaps why her hand is in shot, to help fill the empty space.

You can shoot two people talking in the back seat with this set-up. Shoot a close-up for each, and also try for a wider shot that shows their interaction. If the person in the back seat is communicating with the driver or front seat passenger you'll also need to use the Back Seat Shooting technique in the next chapter.

Girl, Interrupted. Directed by James Mangold. Columbia Tristar Home Entertainment, 2000. All Rights Reserved.

BACK SEAT SHOOTING

This shot complements the Front Seat shot from the previous chapter, and can be used in the same sequence. In essence, you sit the camera operator on the back seat, and shoot the driver or front seat passenger.

As can be seen from this example, the trick is to get the driver's face in shot. When you're shooting the passenger, it's not so much of a challenge, because the passenger can legitimately turn around to look into the back seat. The driver, however, needs to watch the road. This is especially true if your actor is actually driving the car.

The solution is to have the driver only glance around, and look in the mirror. Use a longer lens for the mirror shot, as you want the eyes to be clearly visible. Focusing on a mirror image can be tricky, so double-check the focus.

This set-up works well when the main character is in the back seat, and the character in the front seat is of less importance. (If the front seat character was more important, you'd probably put the camera in the passenger seat and film him from there.)

By shooting briefly from the back seat, you create the slightly disconnected feeling typical of a taxi ride. It can make the passenger seem a little isolated and unsettled, as the communication is all through glances, reflections and slight turns of the head.

Girl, Interrupted. Directed by James Mangold. Columbia Tristar Home Entertainment, 2000. All Rights Reserved.

CAR DIALOGUE

You can achieve excellent in-car dialogue, without having to use car-mounts or complex rigs, by shooting from the back seat.

As you can see from this example, the actors need to look across at each other for their expressions to be clearly in frame. This will mean that the non-driver gets far more coverage than the driver, because the driver will have to spend most of her time watching the road.

As always, slow driving will give an impression of reasonable speed, so don't rush. Give your actors plenty of motivation to look at each other; this shouldn't be a casual chat, but a conversation that forces them to make eye contact.

For each set-up, put the camera on the opposite side of the car to the actor. The actor who's driving should be framed hard on the left, and the actor on the right should be framed hard to the right.

Having the windows slightly open, as shown here, can disturb the sound, but does add a bit of energy to the scene, as it makes the actors' hair flutter in the breeze.

White Oleander. Directed by Peter Kosminsky. Magna Pacific, 2002. All Rights Reserved.

THE PARKED CAR

Many scenes take place in parked cars, and because the car's not moving you have a bit more flexibility in your shooting approach. Although you could simply put the camera in the backseat, as shown in the previous chapter, you don't have to do so.

By placing the camera outside the car, you can use a longer lens. This helps the audience to focus on the actors, and their dialogue, rather than on the surroundings.

Set up your cameras outside the car, as shown in the diagram. Your actors will need to lean forward, in most cases, depending on the construction of the particular car you're using. This forward lean makes the conversation seem important, so only use this technique when the conversation is truly engaging to the characters.

To avoid shooting through glass, open the door, or put the window down. Every car is different, but by using a long lens and opening windows and doors, you should be able to find an angle that gives you a good shot. To the audience, it should feel as though we're in the car with the actors. Ask your actors not to move too much, because their motion may make the car chassis wobble around at the edge of the frame.

Sideways. Directed by Alexander Payne. Twentieth Century Fox Home Entertainment, 2004. All Rights Reserved.

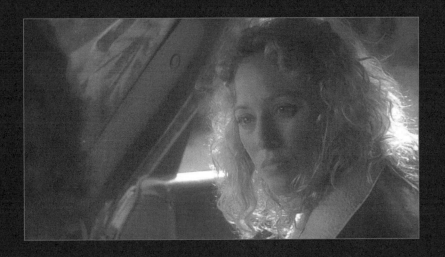

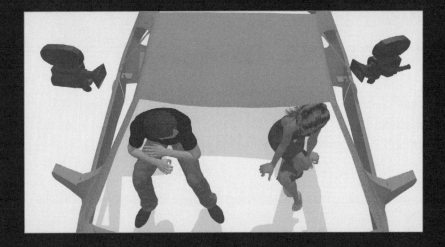

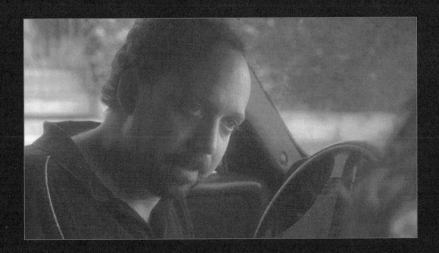

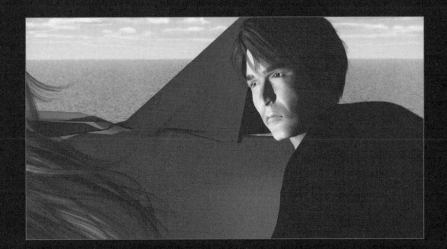

LEAVING THE CAR

Transitional shots, where somebody moves through a doorway, can be a moment of power and interest, or a moment of boredom. This is never more true than with car doors. If you're not careful, then getting into or out of a car is nothing more than passing time, and does nothing to keep the audience interested. If you need to see your character get out of the car, you need to make it interesting.

One way to do this is to identify with the actor closely, by staying on her level and moving in to a tighter framing as the scene progresses. When the shot begins, in this example, the camera is at head height. The framing is attractive enough to keep the viewer interested, and as she stands up, the camera rises with her. Some time during this transition, a cut is made to a medium close-up, with a longer lens. This draws us into the character's world, and helps us identify with her. It's a subtle difference, but it's far more interesting than just pointing the camera at somebody as they get out of the car.

You can set your camera up in one position, at head height, and simply follow the actor's movement, then repeat with a longer lens. It also helps if the actor is looking almost directly into camera, rather than away into the distance. Try to frame the shot so that whatever she's interested in is apparently behind the camera, so she has a motivation to put her eyeline close to camera.

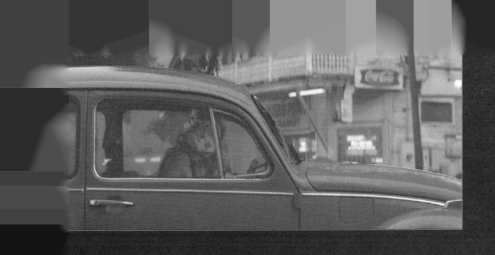

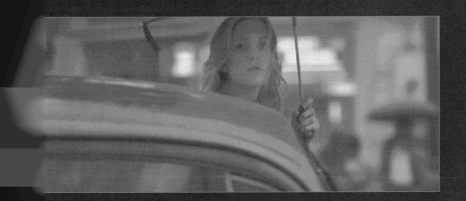

CAR WALK

In the real world, we rarely talk to people in a moving vehicle; it's easier for the car and the person to stop and talk. In film, however, this convention helps to sell the idea that there's a mild barrier between two people. It's used most frequently when one person is trying to coerce the other into their life. The effect can be sinister or sincere, depending on context.

As shown here, the framing is quite simple, with the exterior character framed hard to the right, and the interior character framed to the left. Camera height, though, is crucial in determining whose scene this is. In this example, the camera is at the driver's height for both directions, indicating that we identify with the driver more strongly. If the camera were at the walker's head height, there would be a very different feeling. Some directors choose to put the camera at different heights for each direction, but this can neutralize the scene.

Great care must be taken when shooting these scenes, and the car should barely even move at walking pace. When shooting the driver, set up a dolly, and track along with the car, slightly ahead of the driver, so that he can be framed to the left. When shooting the walker, set up the camera in the front seat (close to the front windshield) so that the walking character is framed to the right.

A long lens helps to separate the characters from their surroundings, but you don't want to cut out the bodywork of the car completely, or the shot can feel a bit disorientating.

Murder By Numbers. Directed by Barbet Schroeder. Warner Home Video, 2002. All Rights Reserved.

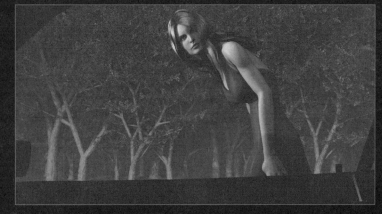

SHOOTING THROUGH WINDOWS

During a stake-out type scene, or where characters are sitting in a car waiting for something to happen, you need a unique set-up. You don't want to have the actors looking at each other, or to rack focus between them as they talk. Instead, you set up a camera angle that focuses on each actor in turn.

In the first set-up the camera is located on the left side of the car, far enough away that a very long lens can be used. This makes the actors' heads appear roughly the same size. This is vital because the farthest actor is meant to be the focus of the shot, and too short a lens will make his head appear relatively small.

The use of a long lens also means that by focusing on the farthest actor, the actor closest to the camera is out of focus. This directs our attention where it needs to be, while still allowing us to see that there are two people in the car. You may need to cheat slightly, and sit the farther actor slightly forward in his seat.

When you want to show the actor in the left-hand seat, you change to a completely different angle. Here, the camera is placed directly in front of the car, with a long lens framing this actor's face for a close-up.

There are many variations on this approach, with cameras at various angles and with different framings. The important point is that whatever angle or framing you choose, only one character should be the focus of attention at any one time. This shot is about watching and waiting. If it's about a conversation, you'll use one of the other set-ups previously described.

Don't Say a Word. Directed by Gary Fleder. Roadshow Home Entertainment, 2001. All Rights Reserved.

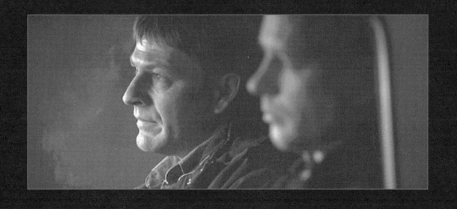

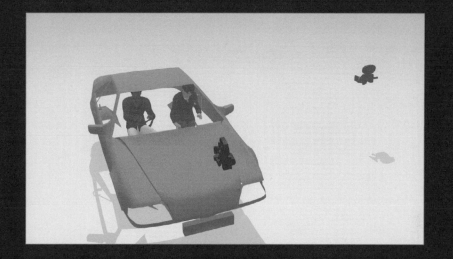

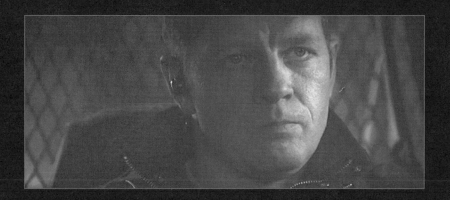

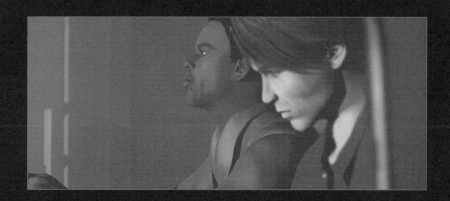

DIALOGUE SCENES

CONVERSATION DOLLY

All too often, dialogue scenes are framed with the characters looking directly at each other, with the editor given no choice by to cut between the two angles. It works, but it can be tedious. An alternative, shown here, is to sit the characters next to each other. At the same time, you push in on the characters, from both angles.

One character should be quite dominant in the scene, as shown in this example. One character is looking directly at the other, who attempts to avoid her gaze.

Whether you're shooting with two cameras at once, or taking each angle in turn, it is essential that your dolly moves happen at exactly the same speed. You'll be cutting between two moving shots, and that only looks good if they move in at the same speed.

A fast push in will create way too strong an effect, so this works best when there is a relatively brief conversation, and the dolly draws us into the intimate power of this moment between two characters.

If your cameras come to rest before the end of the scene, you may find that when you edit, it's more powerful to stay on one angle until the scene ends. Cutting between the two shots after the move is over can seem a little forced. On the other hand, cutting out of the scene while the cameras are moving feels like we're leaving before the conversation is over. Ideally, the camera should come to rest just a couple of beats before you want the scene to end, so you can stay with one shot for a moment, and then cut.

The Quiet. Directed by Jamie Babbit. Sony Pictures, 2005. All Rights Reserved.

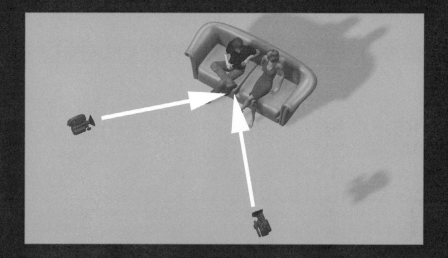

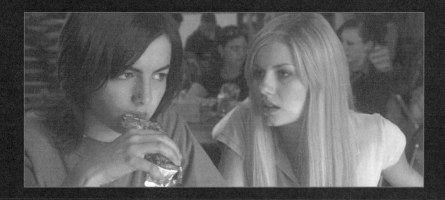

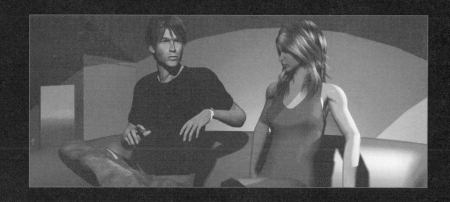

OFFSET BACKGROUND

To make a dialogue scene interesting, you can have one character refusing to look at the other, and use a camera move to focus in on this conflict.

The effect works particularly well if there is a more detailed background to begin with, as shown here. In the initial framing, there are three people. And as the move finishes, there are just two. This means that as the conversation continues, we are drawn to the stubborn character, as the rest of the world fades away.

At the same time, however, the character who's facing him remains in frame, but because the camera is closer to both, the distant actor goes slightly out of focus. This again keeps our focus on the nearest character.

Set up your actors in an L-shaped pattern, and frame the shot behind the main character, as shown in this example. The background can be a corridor, a landscape, or as shown here, another person. Track the camera around, bringing it very close to the face of the nearest actor. As you do, you must pull focus onto him, throwing the background slightly out of focus.

Although you may be tempted to have this character move, the effect is strongest if he remains still. This allows us to pass him, which creates a feeling of resistance that is much stronger than if we follow any movement.

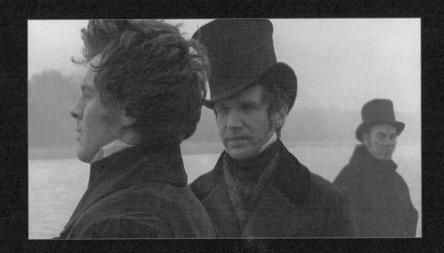 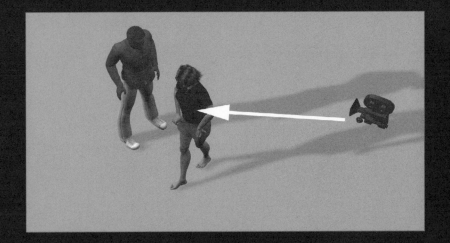

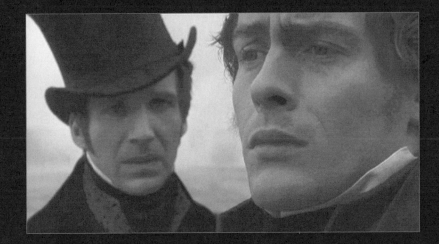 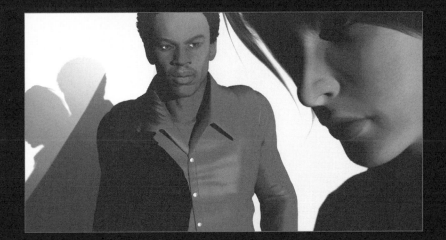

SHARED SCREEN

The classic way to show a conversation is to cut between shots of each actor, as they face each other. Although this is such an established standard that it nearly always works, it does lack cinematic interest. It also means the rhythm of the scene is dictated by the edit, rather than by the actors. If you want an actor-led scene that shows both characters at the same time, you can achieve a more naturalistic feel. In real conversations, people rarely stand facing each other, so when actors share the screen, the shots feel more realistic.

The danger is that you end up with the classic soap opera shot, where one character stands facing the camera, and the other talks to their back. The reason this is used so often in soap opera is that it's an efficient way to show both characters at once. It's such a cliché, though, and so unrealistic, that it can't be used effectively in films, without giving it a twist.

By orienting your actors carefully, you can allow both faces to be seen in the shot at the same time. It works best when the actors are seated, on different levels, or where one actor is moving around the other. It also helps to have the actors glance at each other throughout the scene.

Letting both actors share the screen is potentially less dramatic, because no actor is completely dominant in the shot. Whoever's looking more directly into camera will draw our attention. Without care, you can end up with both actors being shown in profile, which conceals their performances and lessens drama. To make the most of Shared Screen, position your camera so that one actor has a reasonably direct eyeline toward the camera, making them the dominant point of interest. These shots work with zero camera movement, but an ambitious director will move the camera and the actors. You can even switch which actor has the dominant eyeline halfway through the shot.

A Heart in Winter. Directed by Claude Sautet. Gryphon Entertainment 1992. All Rights Reserved.

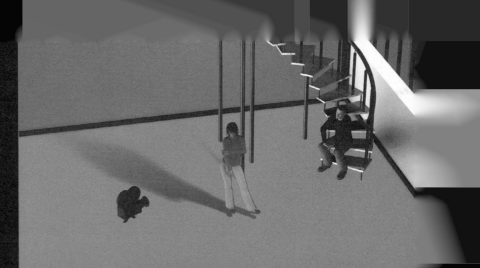
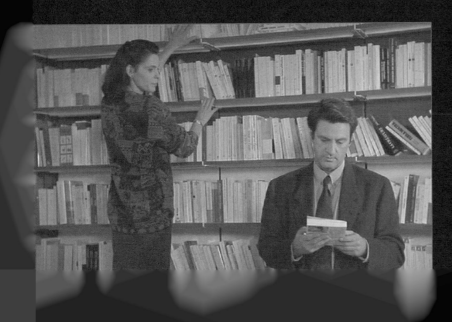
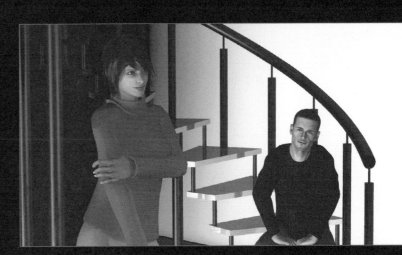

SIDE BY SIDE

You can stage a dialogue scene with the characters standing side by side, but the danger is that they may seem disinterested in each other. If you want them to be engaged with each other's conversation without actually looking at each other, they should be looking at something off-screen that is compelling to both of them.

In this shot, the characters are both looking past (almost directly into) camera, as they watch television. What they're watching is a key part of the plot, so it makes sense for them to be arranged in this way.

Although you can have your actors glance at each other, it's more powerful if they don't. Keep them looking ahead so that the audience gets to see their full reaction. This also means that their only connection is their dialogue, which brings more focus onto what's being said.

Unless you are deliberately teasing the audience, by refusing to show what's off-screen, you will need to cut to a reverse angle, to show what they are seeing. When you do so, it helps if you go behind them, so that they are then included with the subject of their gaze. To simply cut to the subject that they are looking at has the potential to disorient the audience. Also, by placing them in the shot, you maintain the strong connection between them that has been built by this set-up.

You may also find it helpful if this second shot is at a different height than the first shot. If your actors are looking ever so slightly down, then place the reverse angle camera higher up.

Amélie. Directed by Jean-Pierre Jeunet. Becker Entertainment, 2001. All Rights Reserved.

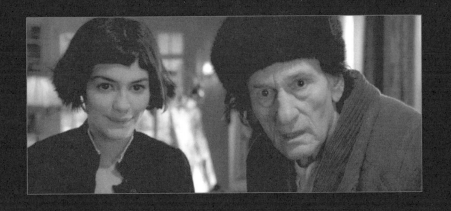

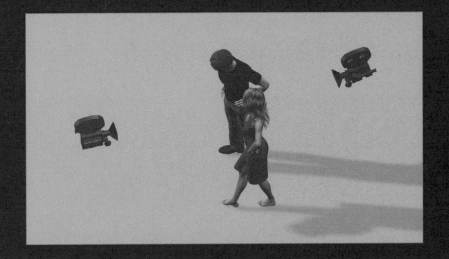

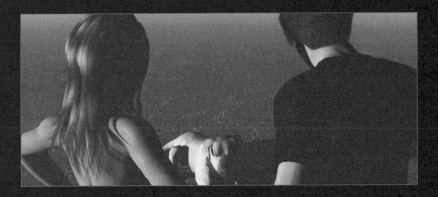

HEIGHT CHANGES

Good directors are always looking for interesting ways to stage dialogue, because anything is better than having the actors stand across from each other. A common solution is to put them at different heights. As always, this has to be justified by the story and the relationships they are exhibiting.

In this set-up, both cameras are at the head height of the actor they are filming. This means that both cameras are level with the horizon. Often when people shoot actors at different heights, they tilt the camera down at the kneeling actor, and tilt up at the standing actor. This set-up, where there is no tilt, is more unusual, but also more intimate. The camera is taking a cold hard look at each character as they respond to the other. It is a very bold and direct technique, but if the scene is strong enough, it makes the dialogue powerful.

One way to shoot this would be to fill the frame with a single actor, with no part of the other actor showing. The problem with this is that, because we are not using the tilt-up/tilt-down technique, the eyelines are far from normal and the audience can become disoriented. It helps, therefore, if you set up the lower camera so that it includes both the actors. In this example, only Brittany Murphy's arm is showing, and that is enough for us to see how the actors are positioned. In the reverse shot of her, there is no need for any part of Michael Douglas to be visible, because the audience is already well oriented.

Cutting between different focal lengths rarely works with dialogue, but when you're shooting at different heights you can get away with it. The more intense character can have a shorter lens, to look slightly distorted and to exaggerate her movements.

Don't Say a Word. Directed by Gary Fleder. Roadshow Home Entertainment, 2001. All Rights Reserved.

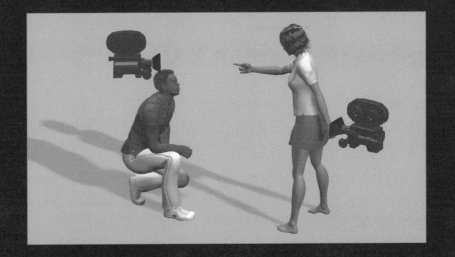

STAGED GLANCES

When people sit next to each other, you can use their glances at each other to emphasize a developing relationship or to show nervousness. This is much more compelling to watch than having both characters stare at each other directly. It works particularly well when the couple are still getting to know each other, as shown in this example.

Your actors should be sitting on a shared piece of furniture, with one being more open than the other, angling her body toward him. In this scene, this is her house and she's more confident and interested in him, so it makes sense for her to face him. If he were to face her as directly, it would be a very different scene. As it is, he faces forward most of the time, and only turns his head to glance at her. When he does, it is a powerful moment, and more moving for the audience than if he was looking at her the whole time.

The camera set-up is extremely simple, with a camera at head height for each actor, at roughly the same distance and angle. Both shots should be slightly over-the-shoulder, so that the two characters are connected at all times.

A set-up like this is very much based on the actors' performance. It must make sense for one character to angle her body, while the other must have a good reason to avoid eye contact. If this does make sense for the script, the set-up works extremely well and the restrictions of a confined working space often help the actors find a performance.

Sideways. Directed by Alexander Payne. Twentieth Century Fox Home Entertainment, 2004. All Rights Reserved.

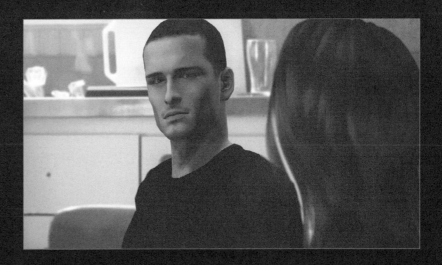

MIRROR TALK

A good way to keep both actors' faces on screen while they talk is to have them look at each other in a mirror. It helps, however, if one is behind the other.

By placing one actor behind the other, it enables you to frame the more distant character in the center of the screen, thus giving him more impact. Even if his face is hidden in shadow, this centralization helps to make this character stand out more. This is important because, being further away from the camera, he will appear too small and insignificant if framed to the side.

When you place him in the center, however, you should ensure that the other character frames him on either side; reflected face on one side, and shoulder on the other. This framing is quite claustrophobic, so it's good for arguments or conflicts.

If framed well, the central character will almost appear to be looking directly into camera. This very tight eyeline helps us identify with him, and means he is the dominant character in the scene. The actors only need to look at each other, and you will achieve this eyeline effect, so long as your camera is as close to the actors as possible.

36 *Quai des Orfèvres*. Directed by Olivier Marchal. Madman Films, 2004. All Rights Reserved.

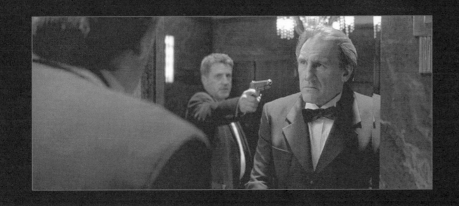

MOVE WITH THE BEATS

People often talk as they move, and so do characters. The problem for a director is how to make the camera move interesting, rather than just tracking along with the characters as they move. One creative solution is to have the camera move according to the changes in intensity that occur in the story.

In the example shown here, the camera begins by dollying back as the characters walk down the corridor talking. This is a classic backward-dolly two-shot. But then as the characters move into the room, the camera turns and backs away from them. This is at the moment that their discussion turns to a more conflicted one. They turn to face each other and the camera makes space for the argument.

Then, after a slight pause, the camera begins to dolly back toward them as the intensity of the conversation moves up another step. This is much more interesting than if the camera had simply stayed with them, or dropped into a medium close-up of them talking.

Seeing characters from the side is never as intense, or as revealing of character, so you should use this shot when you are trying to communicate the relationship between two characters, or the subject matter they are talking about. If you want to reveal an important plot point as the characters talk, this is an ideal technique because you don't want to be staring into an actor's smoldering eyes when you're meant to be listening to important information.

Don't Say a Word. Directed by Gary Fleder. Roadshow Home Entertainment, 2001. All Rights Reserved.

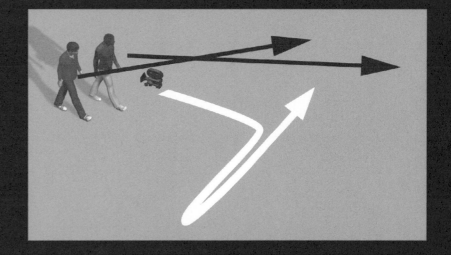

ARGUMENTS & CONFLICT

CIRCLING

A strong way to show characters on the brink of an argument, but trying to hold the conflict in check, is to have them circle one another, almost like animals. This sounds like a relatively simple shot, but there are a few subtleties that help make it work well.

There should be a dominant character who motivates the circling. Here, Hayden Christensen is the one who begins to walk around Ian McDiarmid. This means that Christensen's body is side-on throughout the shot, whereas McDiarmid is facing directly toward camera. This makes Christensen looks like he's prowling, whereas McDiarmid is defensive. This is essential for setting up the power struggle between the characters.

Also, when one character begins circling, there is the temptation for the second character to just turn in a circle on the spot, but this tends to look ridiculous when edited into the final sequence. Instead, the second character should also turn in a circle, but this should be more of a side-stepping shuffle, so that he continues to face the main character directly.

You can cover this in many ways, with stationary cameras and circling cameras, but one of the best ways is to shoot two simple versions. In the first, the camera takes the place of the dominant character, and films the second character face on, almost as a Point of View shot.

For the second set-up, you should be behind the second character, in an over-the-shoulder set-up. In both shots, let the actors dictate the speed of the movement, and have the camera follow.

Star Wars: Revenge of the Sith. Directed by George Lucas. Twentieth Century Fox Home Entertainment, 2005. All Rights Reserved.

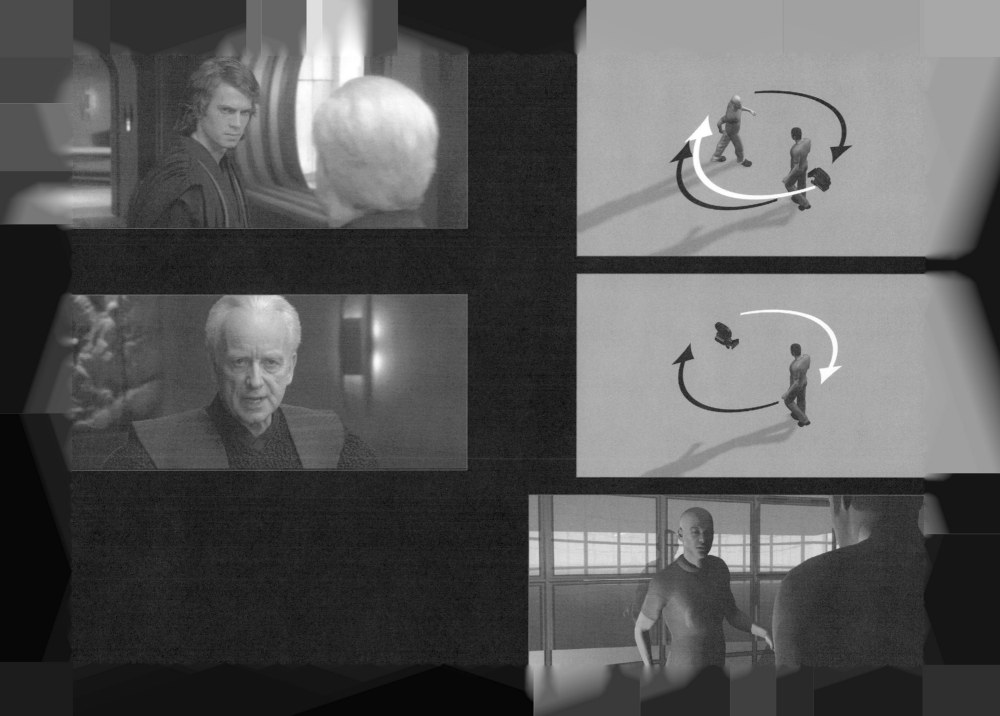

ATTACKING CAMERA

In some arguments, both characters exhibit an equal level of intensity, but in most filmed arguments, there is one dominant character pushing the argument along. This can switch mid-scene, at times, but it always helps to know who's the more dominant character. This knowledge enables you to use the camera to lunge at the more submissive character.

In the example shown here, Winona Ryder only backs off a short distance, but the camera moves toward her faster than she's getting away. This makes it feel as though we are attacking her. It helps that the shoulder or hair of the second character occasionally brushes into the left-hand side of the frame. This is not an over-the-shoulder shot as such, but those glimpses of the other character help add to the sensation generated by the camera.

It helps if you frame the character hard to one side of the frame, as this constantly makes us feel that the attacking character is actually going to lunge into the empty frame.

Although you may be tempted to lunge the camera in jerking movements, you can create a more impressive look if the camera moves in steadily, even though the actor moves back in uncertain, jerking motions. As always, on-set experimentation at the last minute will help you decide.

Girl, Interrupted. Directed by James Mangold. Columbia Tristar Home Entertainment, 2000. All Rights Reserved.

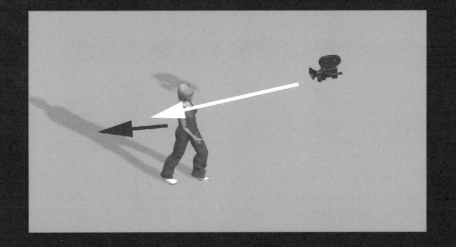

DEFENSIVE CAMERA

Sometimes the smallest of camera moves have the greatest effect. If you want to show that a character is getting the upper hand in an argument (in terms of emotional intensity) you can move the camera backward a little. It sounds absurdly simple, but there are a few more steps to make this work well.

You should set up your camera in front of the second character, and then back off slowly into a slight over-the-shoulder shot. The move should not be too sudden, but a gentle move away from the main character.

If the main character moves toward the camera at the same time, some of the power of this effect is lost. A good solution, as demonstrated by Spielberg in this example, is to have the main character moves backward and forward as she argues. This is realistic: people in arguments do move forward, back off, and then move forward again.

By blocking the actor in this way, and moving the camera back, you create the effect of a defensive feeling in the second character, rather than making the first character feel aggressive. Her movements are dictated by her emotions, and the camera's movement reflects the defensiveness of the second character.

Artificial Intelligence: AI. Directed by Steven Spielberg. Warner Home Video, 2001. All Rights Reserved.

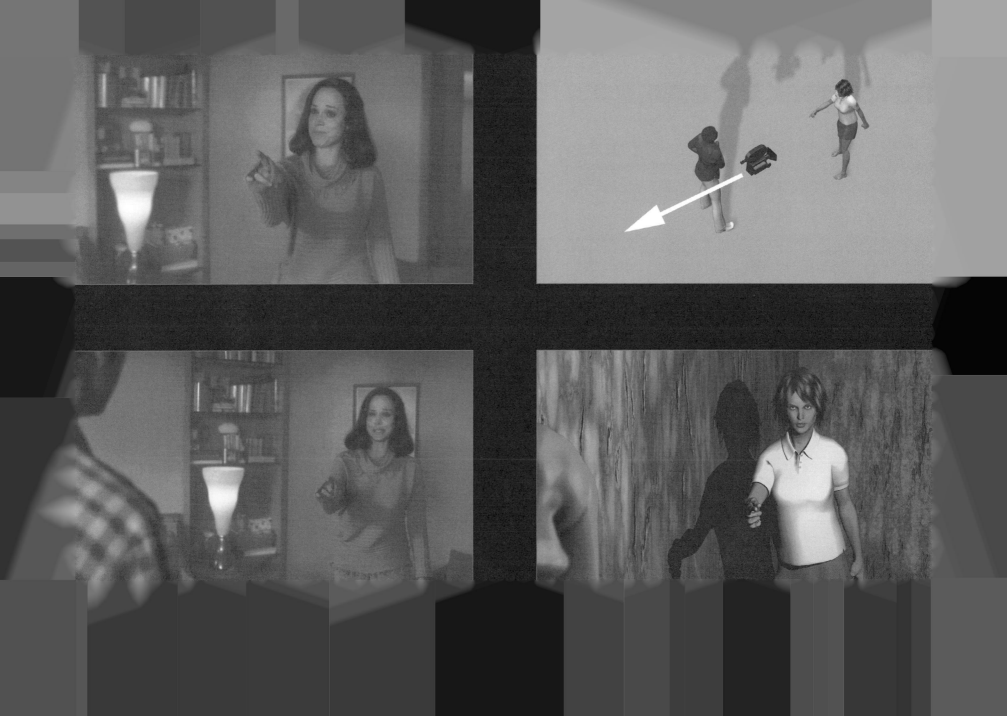

LUNGING AT CAMERA

One of the best ways to show powerful aggression in an argument is to keep the camera exactly where it is, and have the actor move toward it suddenly. As can be seen in this example, the actor should be tightly framed to begin with, so that any forward movement feels like an intrusion.

When you want to exaggerate movement, you often use a short lens; this would have the effect of making a short forward movement seem larger. In this example, however, that doesn't quite work, as it creates too comical an effect. Instead, use a long lens, and frame the face tightly. When the actor moves forward, the framing will not change too abruptly because of the lens choice.

For the lunge forward to show up at all, however, your actor will have to move forward at least a foot. It may feel unrealistic to the actor, so you will need to reassure them how this is going to look on camera. Some actors find this kind of exaggerated lunge actually helps with their acting, because they are being given permission to go to the extreme for just a moment.

You can make the camera flinch, slightly, at the moment of the lunge, or cut to the second character, and show his reaction.

State and Main. Directed by David Mamet. Twentieth Century Fox Home Entertainment, 2000. All Rights Reserved.

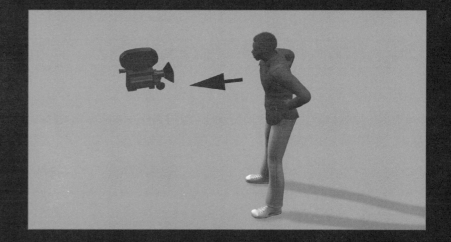

MOTION IN ANGER

Two common techniques used to emphasize drama can be combined to make a moment of high impact in an extreme argument. The whip pan and the push in, when combined, create an unusual but potent effect. In the example here, the camera pushes forward, but as the gun swings to the right, the camera whips to follow it, reframing the character on the left. The two moves create a real sense of panic.

This works best when your actor is carrying a gun, waving his fists, or has something else to move across the screen. He should be pointing, or moving something, from one side of the screen to the other, so that as you push in, you have a motivation to whip to the other side.

The most important thing to get right is the timing. You don't want to be following the actor's movement, but you should be moving at the exact same speed. This will require rehearsal, and a good operator who should be worrying about nothing else other than the whip pan. Let everybody else handle the focus, dolly move, and other aspects of the shot.

Romeo + Juliet. Directed by Baz Luhrmann. Twentieth Century Fox Home Entertainment, 1996. All Rights Reserved.

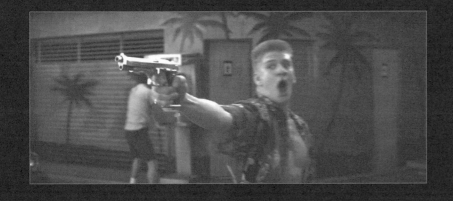

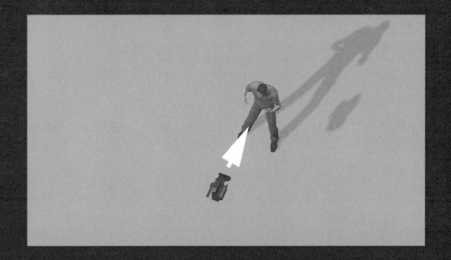

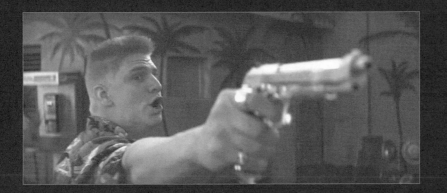

BODY CONFLICT

Arguments and conflicts are often at their most interesting when the intensity and aggression dies away, and the final stages of weary diplomacy take over. This is particularly true when the argument is between a couple. Are they trying to make up, or are they continuing to argue?

In this set-up, most of the acting is done with the actors' bodies, so rather than using a complex move, set up the camera so that you can see their bodies, and the way they relate to each other. Have them both facing the camera, lying down. This has the effect of one character ignoring or shunning the other, while the other is trying to get attention and be heard.

Resist the temptation to move the camera at all. Keep it on their level, and don't pan to account for their movement. You will need to instruct the actors to stay in roughly the same place to assist with this. Their movements should be subtle, with the sense of resistance leading to a great stillness. This will help the audience to focus on the emotion and meaning of their words.

Romance. Directed by Catherine Breillat. Madman Films, 1999. All Rights Reserved.

BACK OVER SHOULDER

Arguments work well when your characters are on the move. Rather than having both move along together, it can help if one is fleeing the argument — not out of fear, but because she believes she has won and there's nothing more to say. Of course, in this scenario they do keep talking, even though she's acting as though the argument is over.

In this example from *Stealing Beauty*, the two characters rush along, and the camera tracks with them. Their distance from each other does not change, and the camera does not get any closer. This means the focus is on them and their relationship. To enable them to have a conversation, however, the leading actor has to look back over her shoulder. It is essential that she does this by turning in the direction of the camera and crew, so that the audience gets to see her face.

If she doesn't turn around, but speaks as she heads away, this can still be realistic, but indicates a more profound argument. When the character looks back over her shoulder, she's still in the argument, even though she's pretending to leave it.

You'll want to use quite a long lens, which means that however you choose to track the camera you'll need to keep it as stable as possible, to avoid the camera shake that can be induced by using a long lens.

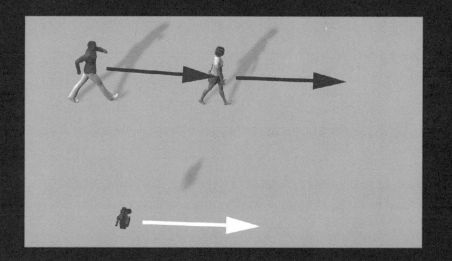

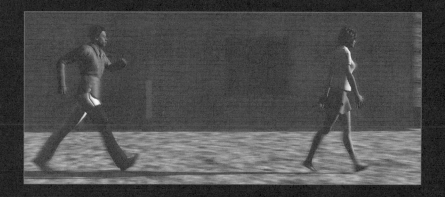

CRISS-CROSSING

You can create a dynamic argument with almost no camera movement by setting up the camera with a short lens and letting the emotion come from the actors' movement.

In this example from *Hour of the Wolf*, Max von Sydow is so intent on avoiding the argument (at least at face value) that he walks away from Liv Ullmann. This brings him toward camera, so we see his bad-tempered face. Although she is close behind, the short lens makes her seem distant, but closing fast.

They then turn to face each other, but again he takes off, side-stepping to the right of her, but heading to the left of the screen. This pattern continues, with the characters crossing each other's paths. The diagrams make this clear, with the black lines indicating how they cross paths repeatedly. If they only moved backward and forward, this scene would feel forced and unreal, but because they are half-circling, and going first one way and then the other, it has a great deal of realism.

Although you should give your actors some freedom, it is important that they cross each other's paths, otherwise it just feels like one character is trailing after the other. Include several changes of direction, and the scene will work. You can even pause during this scene for face-to-face conversation and achieve the entire scene without a cut.

Hour of the Wolf. Directed by Ingmar Bergman. MGM Home Entertainment, 1968. All Rights Reserved.

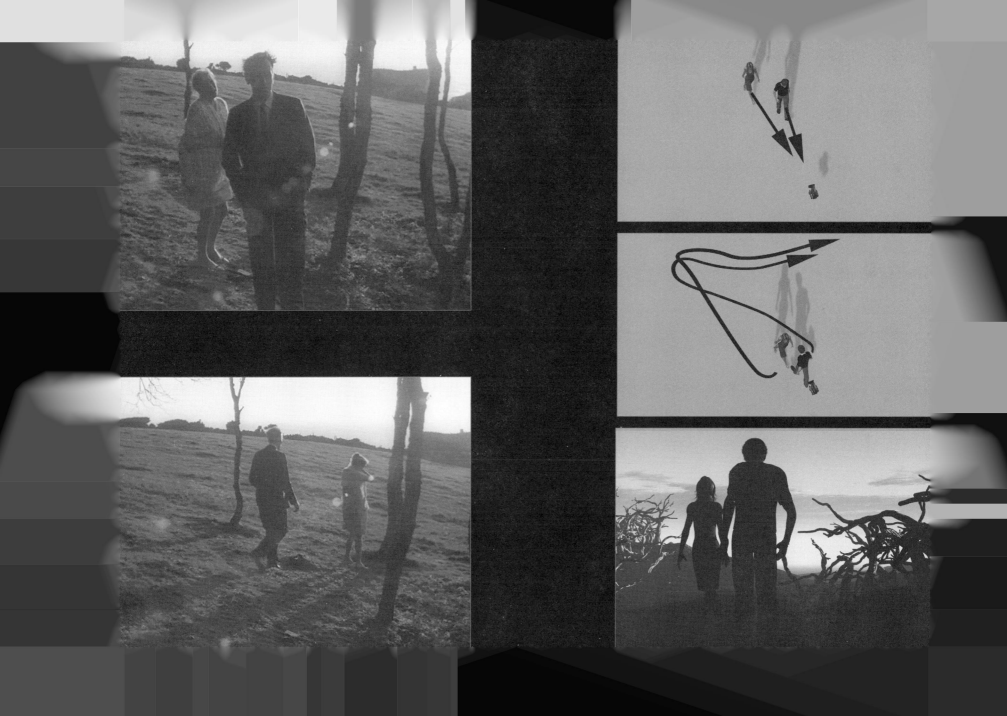

LOVE & SEX SCENES

EYE CONTACT

When the chemistry is right, a powerful look between characters that are falling in love is one of the most enduring images in cinema. Actors and directors pray for these moments. Love should be written all over their faces, so that we can see it clearly even though the characters aren't acknowledging it out loud.

There is a technique, using an extremely simple camera set-up, which helps to get this moment right. You will still need to do all the creative work getting the actors to perform, but this set-up and approach will ensure that it's captured in a way that makes it work on screen.

For this moment to work, you need to create some visual tension. You do this by having the characters avoid looking at each other for most of the scene, even if they are talking and standing close to one another.

Then, when they do look at each other, they take turns. In this example from *A Heart in Winter*, Daniel Autiel looks at Emmanuelle Béart only when she looks at the violin. And she only looks at him when he's looking away from her. They're so studiously avoiding eye contact that the audience can't wait for them to look at each other. This goes on for half the scene, and then they look at each other. The moment is complete. If the director had simply had them looking at each other throughout, the moment where they felt love might not have been clear to the audience.

Your actors can be arranged in many ways, but the arrangement here works well. They are ostensibly facing each other, but they keep turning their heads, and most importantly, their eyes, away. The camera should be at the height of the character being observed. Don't give each character their own frame — the other character should always be present at the edge of frame.

A Heart in Winter. Directed by Claude Sautet. Gryphon Entertainment 1992. All Rights Reserved.

FIRST CONTACT

An audience is always waiting for the first on-screen kiss, but it remains one of the most difficult scenes to shoot with any elegance. Kissing is, after all, something that hides the face, and what we can see of the face is often bent and crushed against the other person's face. It takes careful framing and precise body-acting to get this to work.

Ideally, you want to be able to see the actors' faces immediately before and after the kiss. It's their expectation and reaction that counts. A standard over-the-shoulder shot will not work, because the actors are too physically close, so you need to move the camera further around. This has the effect of including one actor's face, while the second actor is also clearly in the shot – albeit with his back to us. This is much more satisfying than an over-the-shoulder shot, given that we are trying to achieve a sense of romance.

When the kiss itself happens, however, these angles are not generally satisfactory, as too much face is hidden. It's better to have a camera perpendicular to the actors.

When the actors kiss, one of their noses will get hidden behind the other – this is unavoidable. You don't want one actor to completely shield the other actor, so the least tall actor (usually the woman) should tilt her head back more than would feel normal for a real-world kiss. This slight angling back helps to keep more of her face in shot. It's a highly technical thing to request of an actor who's trying to achieve a convincing kiss, and not all actors will be happy to comply, but it is worth trying to keep as much of her face in shot as possible.

The moment the kiss is over, cut back to one of the other angles, so we can see their reactions.

Romeo + Juliet. Directed by Baz Luhrmann. Twentieth Century Fox Home Entertainment, 1996. All Rights Reserved.

KISS ANGLES

In the previous section, First Contact, we showed how three angles could be used to show the main elements of the kiss. Instead of shooting from three angles, you can swing the camera around the actors, to cover the same angles in a move.

As you can see from this example, this works best if the camera is slightly above the actors, looking down at them. This approach also makes it possible for one character to dominate the scene, rather than having it be a shared moment. Here, Liv Tyler's character is the subject of the scene, so the camera passes behind the male actor. It's her face that we see most clearly at all points throughout the kiss.

Most people, when they kiss, lean to the right. In film, however, we need a little more variety, and in a shot like this, it helps if the actor who is facing camera changes the angles of her head as the camera moves. At the beginning of the shot she is leaning toward the camera, and by the time the camera has swung around behind the other actor, her head has angled toward the camera again. This isn't always essential, but is important if you want the scene to be more about her than about them as a couple.

You can also see how she has angled her body away from the other actor. This may be because it makes for a more beautiful framing, or because of the character's reluctance to kiss, but it is the sort of detail you need to be aware of. Most kissing scenes are shot poorly, and it's worth trying to be better than average.

Stealing Beauty. Directed by Bernardo Bertolucci. Twentieth Century Fox Home Entertainment, 1996. All Rights Reserved.

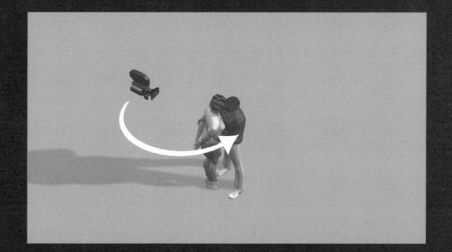

GETTING DOWN

If your kissing scene is to progress to a more sexual one, then at some point you probably need to get the characters to lie down. This can be quite awkward to film, but there are a few elegant solutions. One of the more beautiful ways is to cut from the kiss to a shot of an empty bed, and then have the characters fall back into the shot.

One of the benefits of this technique is that it eliminates a potentially awkward moment where the actors stop kissing and begin to move toward the bed. If you want this to feel like a flowing sex scene, rather than an awkward one, the cut to empty space can solve your problem.

At this point you may want your characters to talk more, to kiss more, or to undress each other, and this set-up has the advantage of being suitable for all three.

There are a few pitfalls to avoid. Be careful not to have the lower character fall back too fast, or there can be a trampoline effect which looks comical. It's also best if they move into shot almost as one; if one falls back, and then the other falls in later, the result can again be comical. It should look as though they have simply flowed out of a kiss and into this position.

This works best when the characters are not actually in an embrace, so you can put a little space between them before the intimacy is resumed.

Murder By Numbers. Directed by Barbet Schroeder. Warner Home Video, 2002. All Rights Reserved.

OUT OF BODY

Some of the finest sex scenes ever shot show almost nothing of the bodies, but concentrate on the actors' faces. You can even shoot such scenes where the actors are almost completely clothed (so long as this makes sense story-wise).

For this to work requires exceptional actors, but you may find that any actor will enjoy the challenge of a sex scene that is largely about the work they do with their faces and their feelings, rather than how much skin we get to see.

Set up your cameras so that both actors' faces are in shot. As you can see from these examples, the actors should not be facing each other directly, but have their faces close. There are many ways to achieve this, and a thousand variations, but essentially you are trying to get both faces in shot as much as possible, while making it plausible that they are exploring each other's bodies (and eventually making love).

The camera can either be at their head height, or slightly above, and it's best to begin this with a fairly tight framing. You can move further out as the scene progresses, to reveal more of their movement, and more of their bodies if required, but keep their faces angled toward the camera so that the focus remains on their expressions. It's how they see each other, rather than what we see of them, that matters most.

Enemy at the Gates. Directed by Jean-Jacques Annaud. Roadshow Home Entertainment, 2001. All Rights Reserved.

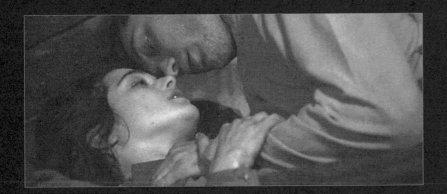

FACING UP

One of the great challenges with intimate scenes, as has been expressed many times, is trying to keep both actors' faces in view at once. In this example, the effect is achieved by careful positioning of the actors within the frame.

The woman is lying back, and although she is in conversation with the man (as they engage in foreplay), her head is thrown back to some extent. She's turned it more toward the camera than toward him. He continues to simulate making eye contact with her, even though he probably can't see her eyes.

The man is also laying off to one side of her slightly, because if he was laying directly on top her of, her body would be obscured and his head would be at the wrong angle. Although this shot looks easy and comfortable, it is actually quite precisely staged and may be quite difficult for the actors. It does, however, enable you to achieve a beautiful framing, without being a gratuitous body-shot. It works best for scenes where the characters are still talking, rather than just having sex.

Romance. Directed by Catherine Breillat. Madman Films, 1999. All Rights Reserved.

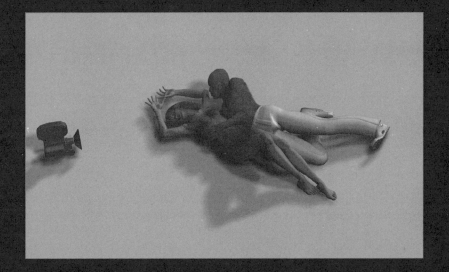

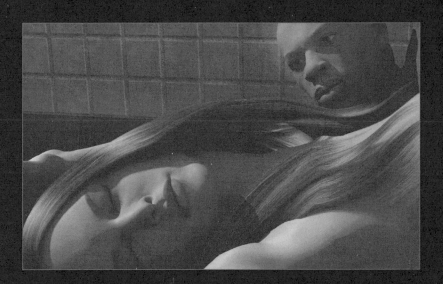

MOMENTS OF CONNECTION

When the talking is over, and the scene is more about body contact and eroticism, it takes skill to reveal the right details without looking forced. In this example the camera captures just a glimpse of Ziyi Zhang's face as she throws her head back. Then we see her ribs, and the man's hands on her body.

This type of set-up is highly erotic as it takes the focus away from the faces and directly to the body. It is also worth noting that this is probably far more erotic than if she were naked, because of the expectation it brings; expectation and suggestion are more erotic than pure observation of a naked body.

The follow-up shot moves to an unusual angle, looking back down at the two of them, so that her face is upside down in the frame. In fact, her face takes up only a small part of the frame, and the mingled bodies fill the rest. Because the two of them appear to be upside down, this captures the dizzying sensation of an electrifying sexual encounter.

Crouching Tiger, Hidden Dragon. Directed by Ang Lee. Columbia Tristar Home Entertainment, 2000. All Rights Reserved.

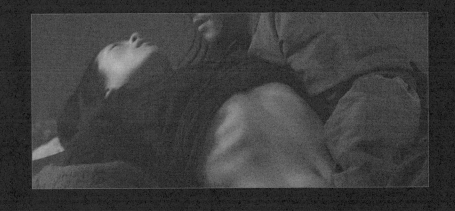

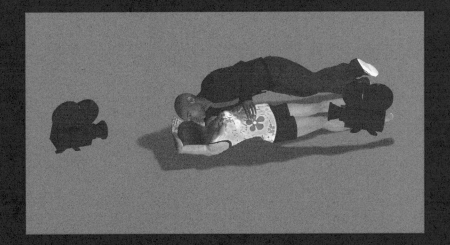

A WORLD OF DETAILS

When directors shoot sex scenes they often want to achieve a sense of great eroticism, but without a hint of pornography. One way to achieve this is to attempt to capture the sensation of actually having sex; rather than observing two people, why not put the camera right in there with them so we feel we're part of the experience. That way we feel the movement and scuffle of clothes and bodies, and catch glimpses of the tiny details of clothing and flesh, just as we do in the real world.

This one brief shot, from *Stealing Beauty*, shows nothing more than a blurred hand, shadow and a hint of bra. A long lens has been used, to throw everything out of focus but the bra. This brief moment is one of many glimpses that make us feel the proximity of this sex scene. Although we also cut back to see the two lovers kissing and touching each other, it is these glimpsed moments that draw us into their experience and make it one of the most sexually charged scenes on film.

Stealing Beauty. Directed by Bernardo Bertolucci. Twentieth Century Fox Home Entertainment, 1996. All Rights Reserved.

CONCLUSION

When you direct a film, you have a lot on your mind. The hours are long, sleep is short, and the pressure is high. And yet, in the midst of the circus, you are required to be as creative as you have ever been. As well as getting a strong performance from your actors, you need to shoot in a distinctive way that reflects your story. This is no easy task.

Writing this book helped me realize that the more intimately I knew technique, the easier it was to create under pressure. Time is always running out on a film set. After months or years of thinking about a film, you often have just moments to make a new choice or solve a problem. And then you live with that decision forever. To people who've never worked in film, it seems implausible that we can spend 12 hours getting two minutes of usable footage. For those who work in the industry, it seems like a miracle if we get that much. I hope this book will help you to develop a way of seeing shots, and thinking up your own, that will make you able to work creatively when time is running out.

The better you know your craft, the easier it is to create. I've often heard filmmakers say they don't care about technique, or the history of film, and they just like to "be creative". Sometimes that works. But usually you see filmmakers on set just "getting the coverage" because there was a technical problem and they couldn't think of a new solution in time. If they had a bit more knowledge about technique, they could probably have created something better.

This lack of vision is often hidden behind shaky camerawork and fast edits. But if you want to deliberately create a film to communicate a story, you need more control than that. This doesn't mean you have to plan every shot in advance, but when technique becomes second nature, it's easier to be original. Think of Yoda in *The Empire Strikes Back*, telling Luke to unlearn what he has learned. When you know something well enough to "unlearn" it, you are on the path to greatness. Unfortunately, many people think the short cut is to avoid learning the technique in the first place. History shows they are wrong. The better educated you are about all aspects of filmmaking, the better you will be at making films.

Now that you know 100 Master Shots, you are better equipped than most filmmakers. Your task is to adapt them, improve on them, and build your own arsenal of workable shots.

I was inspired to write this book because I saw that there are filmmakers out there who refuse to be average, and who find new ways to create. For them, it's not about popcorn and grosses, but about making a great film. The challenge you face is to avoid being average. It takes a lot of time and effort to direct anything, but by the time you get on set, the pressure to get the job done without mistakes turns many a potential genius into a coward. I hope these techniques inspire you to be courageous in your filmmaking. Whatever the pressure, no matter how tired you are, choose greatness.

ABOUT THE AUTHOR

Christopher Kenworthy has worked as a director and producer for the past ten years. He directed the feature film *The Sculptor*, which played to sold-out screenings in Australia and received strong reviews.

As a screenwriter he's contributed to the development of several TV shows, and wrote for his brother's BBC comedy show, *Scallywagga*.

He is the author of two novels and a handful of nonfiction books. He was born in the North of England, but has lived in Australia for fifteen years.

www.christopherkenworthy.com

chris@christopherkenworthy.com

ACKNOWLEDGMENTS FOR FRAME GRABS

MASTER SHOTS VOL 2
100 WAYS TO SHOOT GREAT DIALOGUE SCENES

CHRISTOPHER KENWORTHY

Building on the success of the best-selling *Master Shots*, this book goes much deeper, revealing the great directors' secrets for making the most of the visual during the usual static dialogue scene. A strong scene is determined from where you put the camera and how you position and direct your actors. This is especially true when shooting dialogue. The techniques in *Master Shots, Vol. 2* ensure that every plot point, every emotion, and every subtle meaning is communicated clearly.

This is the first book to show how important it is to shoot dialogue well. What's the point of opening your scene with a great camera move, if you then just shoot the actors like a couple of talking heads? *Master Shots, Vol. 2* gives you control of dialogue scenes, whether you're shooting two characters or a room filled with multiple conversations.

Using examples from well-known films, the book gives 100 techniques, lavishly illustrated with movie frame-grabs, and overhead diagrams, to show exactly what you need to get the required result. At all times, the techniques have been broken down to their core points, so they will work on a fully equipped Hollywood set, or with the most basic video camera.

"*A terrific sequel to the first* Master Shots. *If there's a cool way to move the camera, Kenworthy has explained it to us. I can't wait to get this book into my students' hands.*"

— John Badham, director, *Saturday Night Fever, WarGames*; author, *I'll Be in My Trailer*

"Master Shots, Vol 2 *will inspire every filmmaker to think carefully about placement and movement of actors as seen through the camera lens. This book increases the reader's appreciation for the critical work of the cinematographer and the director as they speak the language of film through images.*"

— Mary J. Schirmer, screenwriter, screenwriting instructor, *www.screenplayers.net*

CHRISTOPHER KENWORTHY has worked as a writer, director, and producer for the past ten years. He directed the feature film *The Sculptor*, which played to sold-out screenings in Australia and received strong reviews. Recent works include sketch comedy for the BBC's *Scallywagga*, a title sequence for National Geographic Channel, visual effects for 3D World, music videos for Pieces of Eight Records and Elefant Records, and an animated wall projection for The Blue Room Theatre in Perth, Australia. Kenworthy is the author of the best-selling *Master Shots*, two novels: *The Winter Inside* and *The Quality of Light*, and many short stories. Current projects include screenwriting, several directing assignments, and the development of additional *Master Shots* applications.

$26.95 | 240 PAGES | ORDER NUMBER 167RLS | ISBN: 9781615930555

FILM DIRECTING: SHOT BY SHOT
VISUALIZING FROM CONCEPT TO SCREEN

STEVEN D. KATZ

BEST SELLER
OVER 200,000 COPIES SOLD!

Film Directing: Shot by Shot — with its famous blue cover — is the best-known book on directing and a favorite of professional directors as an on-set quick reference guide.

This international bestseller is a complete catalog of visual techniques and their stylistic implications, enabling working filmmakers to expand their knowledge.

Contains in-depth information on shot composition, staging sequences, visualization tools, framing and composition techniques, camera movement, blocking tracking shots, script analysis, and much more.

Includes over 750 storyboards and illustrations, with never-before-published storyboards from Steven Spielberg's *Empire of the Sun*, Orson Welles' *Citizen Kane*, and Alfred Hitchcock's *The Birds*.

"(To become a director) you have to teach yourself what makes movies good and what makes them bad. John Singleton has been my mentor... he's the one who told me what movies to watch and to read Shot by Shot.*"*
— Ice Cube, New York Times

"A generous number of photos and superb illustrations accompany each concept, many of the graphics being from Katz' own pen... Film Directing: Shot by Shot *is a feast for the eyes."*
— Videomaker Magazine

"... demonstrates the visual techniques of filmmaking by defining the process whereby the director converts storyboards into photographed scenes."
— Back Stage Shoot

"Contains an encyclopedic wealth of information."
— Millimeter Magazine

STEVEN D. KATZ is also the author of *Film Directing: Cinematic Motion*.

$27.95
366 PAGES
ORDER # 7RLS | ISBN: 9780941188104

DIRECTING ACTORS
CREATING MEMORABLE PERFORMANCES FOR FILM AND TELEVISION

JUDITH WESTON

Directing film or television is a high-stakes occupation. It captures your full attention at every moment, calling on you to commit every resource and stretch yourself to the limit. It's the white-water rafting of entertainment jobs. But for many directors, the excitement they feel about a new project tightens into anxiety when it comes to working with actors.

This book provides a method for establishing creative, collaborative relationships with actors, getting the most out of rehearsals, trouble-shooting poor performances, giving briefer directions, and much more. It addresses what actors want from a director, what directors do wrong, and constructively analyzes the director-actor relationship.

"I believe that working with Judith's ideas and principles has been the most useful time I've spent preparing for my work. I think that if Judith's book were mandatory reading for all directors, the quality of the director-actor process would be transformed, and better drama would result."

> — John Patterson, Director
> *Six Feet Under, CSI: Crime Scene Investigation, The Practice, Law and Order*

"Judith Weston is an extraordinarily gifted teacher. She doesn't so much explain as she changes your consciousness of the creative process and restores your confidence in it."

> — David Chase, Emmy® Award-Winning Writer, Director, and Producer
> *The Sopranos, Northern Exposure, I'll Fly Away*

"Judith opened a door for me to an aspect of that creative process about which I had never really been aware — acting."

> — Ron Judkins, Academy Award® Production Sound Mixing, *Jurassic Park*

JUDITH WESTON has taught her Acting for Directors workshop for over 20 years throughout the U.S., Canada, and Europe. Her best-selling book, *Directing Actors*, is on the required reading lists of major film schools and is used extensively by working directors in Hollywood and around the world. She also authored *The Film Director's Intuition*.

$26.95 | 314 PAGES | ORDER NUMBER 4RLS | ISBN: 9780941188241

THE STORYBOARD ARTIST
A GUIDE TO FREELANCING IN FILM, TV, AND ADVERTISING

GIUSEPPE CRISTIANO

A career guide for those who have artistic talent but don't know how to harness the power of their own creativity. A visual and straightforward manual describing the various aspects of the storyboarding profession. Filled with career-expanding ideas it also includes tips and advice from a working professional with expertise in film, television, and advertising.

"It is my pleasure both to have had Giuseppe Cristiano work for me, creating terrific storyboards for the Nickelodeon animated series 3 Friends and Jerry, and now to recommend this new book. Succeeding as a professional storyboard artist is not easy. It requires not only excellent storytelling and decent drawing skills but many others as well, all-too-often overlooked in art school: marketing, task management, and navigating the chaos of the get-it-done-yesterday world of film and TV production. This book offers the aspiring storyboard artist an education in all of these. Read and keep *The Storyboard Artist next to your desk. You will not only have the tools to become a better storyboarder: you will have the benefit of a seasoned professional mentor at your side."*

— Ray Kosarin, producer/director, *Daria, Beavis and Butt-Head, Da Mob, The World of Tosh*; animation instructor, New York University's Tisch School of the Arts

"There aren't all that many books widely available on the art of storyboarding (when compared to other creative fields), much less one I've read with such a simple overview on the world of freelancing. Covering (as the title suggests) the worlds of advertising, film, and TV, this is a comprehensive guide to those starting out in the field. I'd also consider this worth a read for those looking to hire storyboard artists — it's always good to know exactly what is reasonable to request of creative professionals."

— Erin Corrado, *www.onemoviefiveviews.com*

GIUSEPPE CRISTIANO is a former comic artist as well as a writer. He freelances for advertising agencies and film production companies throughout Europe and the U.S., and has directed a number or shorts, music videos, and animated films.

Giuseppe Cristiano currently lives in Italy and Sweden. He travels on a regular basis between Europe and the U.S. (where he is planning to relocate in the near future).

$24.95 | 210 PAGES | ORDER NUMBER 175RLS | ISBN: 9781615930838

CINEMATIC MOTION
2ND EDITION

STEVEN D. KATZ

BEST SELLER
OVER 40,000 COPIES SOLD!

Cinematic Motion has helped directors create a personal camera style and master complex staging challenges for over a decade. In response to the opportunities offered by digital technology, this second edition adds essential chapters on digital visualization and script breakdown.

S. D. Katz uses extensive illustrations to explain how to create extended sequence shots, elaborate moving camera choreography, and tracking shots with multiple story points. Interviews with top Hollywood craftspeople demonstrate how to bring sophisticated ideas to life.

Readers will be able to follow links to the MWP website and interact with the author's original storyboards, built in 3D with the latest storyboard software.

"There are a precious few ways to learn the subtleties of filmmaking and challenges of cinematography: Watch great movies repeatedly; go to a great film school; read *Steven D. Katz's* Film Directing: Shot by Shot *and* Cinematic Motion. *The practical and pragmatic information is balanced by the insights of great filmmakers, Allen Daviau, Ralph Singleton and John Sayles.* Cinematic Motion *is the definitive workbook for both the aspiring as well as the accomplished filmmaker."*

— John McIntosh, Chair, Computer Art, School of Visual Arts, NYC

"There are few authors or books that reach 'must-read' status. The works of Steven Katz have achieved this appellation. Cinematic Motion *is a remarkable tutorial for any aspiring or working director. Clear, practical, and wise, the book is an essential guide to understanding and implementing staging for the motion picture medium."*

— Sam L Grogg, Ph.D., Dean, AFI Conservatory

"In Cinematic Motion, *Katz succeeds in breaking down the daunting tasks that a director faces when choreographing actors and the camera on set."*

— Dan Ochiva, *Millimeter* Magazine

STEVEN D. KATZ, who lives in New York City, is an award-winning filmmaker and writer, and the author of *Shot by Shot*, the now classic text on cinematic style and technique.

$27.95
362 PAGES
ORDER # 121RLS | ISBN: 9780941188906

SAVE THE CAT!
THE LAST BOOK ON SCREENWRITING YOU'LL EVER NEED!

BLAKE SNYDER

BEST SELLER

He's made millions of dollars selling screenplays to Hollywood and now screenwriter Blake Snyder tells all. "Save the Cat!®" is just one of Snyder's many ironclad rules for making your ideas more marketable and your script more satisfying — and saleable, including:

· The four elements of every winning logline.
· The seven immutable laws of screenplay physics.
· The 10 genres and why they're important to your movie.
· Why your Hero must serve your idea.
· Mastering the Beats.
· Mastering the Board to create the Perfect Beast.
· How to get back on track with ironclad and proven rules for script repair.

This ultimate insider's guide reveals the secrets that none dare admit, told by a show biz veteran who's proven that you can sell your script if you can save the cat.

"Imagine what would happen in a town where more writers approached screenwriting the way Blake suggests? My weekend read would dramatically improve, both in sellable/producible content and in discovering new writers who understand the craft of storytelling and can be hired on assignment for ideas we already have in house."
– From the Foreword by Sheila Hanahan Taylor, Vice President, Development at Zide/Perry Entertainment, whose films include *American Pie, Cats and Dogs, Final Destination*

"One of the most comprehensive and insightful how-to's out there. Save the Cat!® is a must-read for both the novice and the professional screenwriter."
– Todd Black, Producer, *The Pursuit of Happyness, The Weather Man, S.W.A.T, Alex and Emma, Antwone Fisher*

"Want to know how to be a successful writer in Hollywood? The answers are here. Blake Snyder has written an insider's book that's informative — and funny, too."
– David Hoberman, Producer, *The Shaggy Dog* (2005), *Raising Helen, Walking Tall, Bringing Down the House, Monk* (TV)

SAVE THE CAT!
The Last Book On Screenwriting You'll Ever Need!

BLAKE SNYDER

BLAKE SNYDER, besides selling million-dollar scripts to both Disney and Spielberg, was one of Hollywood's most successful spec screenwriters. Blake's vision continues on *www.blakesnyder.com*.

THE MYTH OF MWP

In a dark time, a light bringer came along, leading the curious and the frustrated to clarity and empowerment. It took the well-guarded secrets out of the hands of the few and made them available to all. It spread a spirit of openness and creative freedom, and built a storehouse of knowledge dedicated to the betterment of the arts.

The essence of the Michael Wiese Productions (MWP) is empowering people who have the burning desire to express themselves creatively. We help them realize their dreams by putting the tools in their hands. We demystify the sometimes secretive worlds of screenwriting, directing, acting, producing, film financing, and other media crafts.

By doing so, we hope to bring forth a realization of 'conscious media' which we define as being positively charged, emphasizing hope and affirming positive values like trust, cooperation, self-empowerment, freedom, and love. Grounded in the deep roots of myth, it aims to be healing both for those who make the art and those who encounter it. It hopes to be transformative for people, opening doors to new possibilities and pulling back veils to reveal hidden worlds.

MWP has built a storehouse of knowledge unequaled in the world, for no other publisher has so many titles on the media arts. Please visit www.mwp.com where you will find many free resources and a 25% discount on our books. Sign up and become part of the wider creative community!

Onward and upward,

Michael Wiese
Publisher/Filmmaker